Gecko Keck

DRAW
GOTHIC

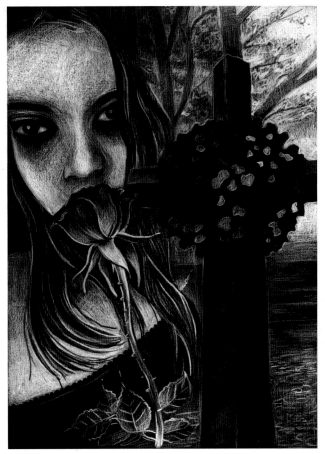

CONTENTS

Welcome to the world of dark art. This book will teach you everything you need to know to become a good Gothic artist, both in terms of technique and content.

Virtually everyone holding this book in their hands will be either a member of the Goth culture themselves or at least working on it. However, for those who are new to the subject and are just discovering a fascination with black, you will find some brief and interesting information below on the history of Goth culture.

The term 'Goth(ic)' (in the sense of 'dark, spine-chilling') arose at the end of the seventies as a description for a particular style of music, from the post-punk period, from which a particular youth culture arose at the beginning of the eighties. The term 'Gothic' has nothing to do with the nation of Goths or the Gothic age, but rather originates exclusively from the British style of music. It was characterised by deep sounds and certain subjects which in their time, as the name suggests, were found to be dark or spine-chilling. Therefore, there is actually no direct relationship between the Goth scene and the Gothic or European Middle Ages, even though there is a broad range of trends within the scene that each individual identifies with.

The term Gothic established itself as a worldwide phenomenon at the end of the eighties in the USA and Canada and then later, at the beginning of the nineties, in Europe.

But enough of the theory. Let us turn to dark art and its multiplicity of stylish variations.

I hope that you will get lots of inspiration from flicking through this book, drawing and learning.

G. Keck

When drawing Gothic motifs, you need to be clear from the start that many things are quite different in the Goth world, including the lifestyle. This particular philosophy of life stands apart from the brash, loud, fashion-led consumer world, and that which was already being expressed via clothes, hairstyle or jewellery has now been translated into art and literature.

Main examples

Music is definitely a main source of inspiration when drawing Gothic motifs. There are countless trends, from very hard sounds to celestial or Middle Age ones. Siouxsie & The Banshees, Joy Division, Sisters of Mercy and later the more commercial band The Cure (to name but a few) are all groups with their roots in the Gothic movement. The scene originally arose from this subculture, whose roots go back to the late punk music at the end of the seventies. Classic Gothic symbols such as spiders, skulls or bats were already to be seen in the videos of the time.

LEARNING OBJECTIVES

In order to become a good Gothic artist, it is first of all important to understand how you can best use this stylish medium. You need to know how to use black successfully in scenes, in all its technical variations, and to create subtle mood pictures from it. In order to achieve this, it is important to master some of the basic drawing techniques.

▶ Shading is an important component of the basic technical vocabulary. In this book, you will learn about the different variations and the purposes for which they can be used.

▶ Black and white form the biggest contrast possible. This means that soft transitions are possible, but so too is the direct contrast of the two extremes of 'colour' against one another. You will learn how to use contrasts in a way that is as atmospheric and striking as possible.

▶ Several difficult techniques are used within the large subject of Gothic art. Drawings of figures and drawings of architecture or plants are both equally important. On the following pages, you will find expert advice on how you can combine the two.

Working with lines means working graphically. Sometimes the crossover with painting in the following Gothic motifs is somewhat fluid, especially when drawing with white pencils or chalk on black paper.

MATERIALS

Anything that makes black or white lines is suitable to use for drawing; in particular, soft drawing materials such as charcoal, graphite pencils or chalk. Very good results can also be achieved with soft pencils, black felt-tip pens, white lacquer pens or even soft coloured pencils. Hard pencils are less suitable.

Pencils

The basic material for creating any drawing is, of course, the pencil. As a good Gothic motif involves the stark contrast between light and dark, it is recommended that you use mainly soft pencils, grades 3B–6B. The grade of the lead is usually marked on the pencil, as follows:

▶ grades beginning with H (H–6H) are hard.
▶ grades beginning with B (B–6B) are soft.
▶ HB lies in the middle.

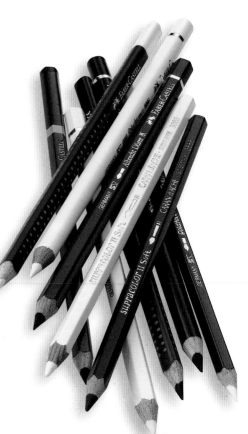

TIP

Coloured pencils, pencils or felt-tip pens are available from any stationer's or department store. Charcoal, graphite pencils or soft chalk pencils are not available everywhere. You can usually find them at a good art shop, along with all types of coloured paper.

Coloured pencils

If you are a beginner, soft black and white coloured pencils are great for your first Gothic motifs. Their drawing properties are very similar to those of pencils, which is why virtually all pencil techniques can also be used with coloured pencils. Make sure when you are working with softer pencils that you do not smudge the work too much. Coloured pencils are more difficult to use, as the strokes are harder to erase than those of regular pencils.

TIP

When drawing, place a piece of paper beneath the ball of your thumb so that the drawing does not smudge.

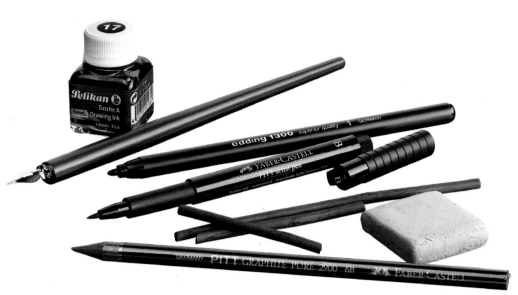

Go for the best quality

When buying drawing materials it is best not to go for the cheapest product. You will only be annoyed later if, for example, the leads keep breaking or the eraser leaves marks.

Drawing surface

Initially, the best drawing surface is simple, white paper. But there are very good and interesting alternatives.

▶ You can achieve great effects on textured grey or black paper, for example.

▶ Other possibilities for giving form to your creative ideas are watercolour paper, drawing card, vellum and even white canvas.

TIP

Drawing with white pencils on black paper is particularly attractive.

BASIC COURSE

7

BLACK

The basic colour of the Gothic scene, black, has its roots in a tradition that has remained constant throughout the years that Goths have existed.

Age-old symbolism

Black has always been the colour of mourning, resignation and melancholy. Nowadays, it is also a silent protest against colourful, short-lived fashion trends. With black clothes and hair it is also possible to disassociate yourself from the environment of your day-to-day life simply and effectively, as well as visibly. Of course, everyone wears black now and again, but you can tell from their style and aura who belongs to the Gothic scene and who does not.

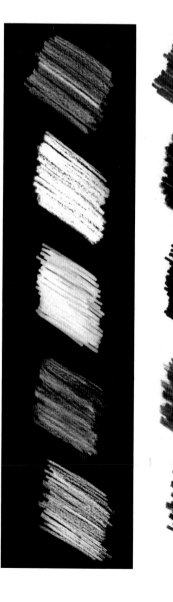

Working with black

The use of black as the basic shade is the most striking stylistic indicator in Gothic motifs – both in material terms and for the melancholic aura that arises from this non-colour.

Find your personal black

In order to best express the black elements of a picture, you should test out in advance which materials you like best and which shade of black you prefer. Not all blacks are the same! In the example, you can see areas that have been drawn with different drawing pencils. The black pencils, from top to bottom, are: soft pencil, graphite pencil, black Edding pen, charcoal and a black coloured pencil.

The same also applies to drawing with white pens on black paper. It is particularly important here that the white appears to give some degree of coverage. Those used in the example, from top to bottom, are: normal white coloured pencil, wax crayon, lacquer pen, chalk and soft coloured pencil.

All about materials

Technically, there are many variations when drawing a subject based on a basic shade of black. The illustrations below give three examples.

▶ Both subjects in the left column have been drawn with charcoal. Charcoal enables you to achieve a very intense, dark black, yet charcoal is very soft and brittle, making sharp contours and small details difficult to depict.

▶ A thick felt-tip pen has been used for the subjects in the middle. The contours are very sharp and the subject takes on a graphic aspect. In contrast to the charcoal, felt-tip pens do not smudge easily.

▶ The subjects in the right-hand column are drawn with a soft, black coloured pencil. This is not only very good for graphic work, but also nice and soft, making it an ideal drawing tool.

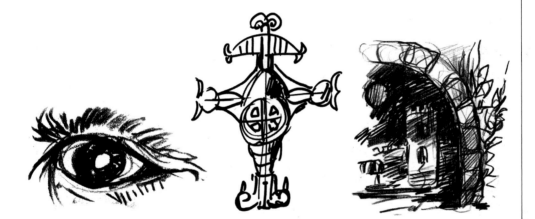

BASIC COURSE

SHADING

The most basic technique when drawing is shading. By using various types of shading, objects can be given a three-dimensional appearance on paper.

What is shading?

Shading means creating a network from individual lines that, when viewed together, give the appearance of a darker or, on black paper, a lighter area. This gives a contrast between light and dark, or bright light and shade. There are three techniques for doing this.

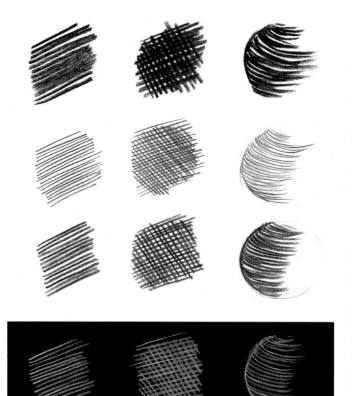

Parallel shading

The left-hand column shows the simplest form. Using this technique, all the lines are parallel. To give the impression of a uniform grey or (for dark paper) white surface, it is important that the distances between the fine lines are as equal as possible. You will need to practise this a little at first.

Cross-hatching

As for parallel shading, all the lines are parallel. To achieve finer detailing after the initial shading, however, you then shade over the top with parallel lines at right-angles to the original ones. This makes an area even darker or lighter. This technique is demonstrated in the middle column.

Form lines

The right-hand column shows the third variation. This is where form lines or form-giving lines are used. These also run parallel to each other, but they follow the form of the object to be drawn and are, for example, curved or wavy. By using this type of shading, you will achieve a very good three-dimensional effect in your drawings.

PORTRAYING VARIOUS MATERIALS

An important aspect of drawing is the graphic representation of different materials, such as stone, wood, fabric, hair or glass.

The eye can be deceived

The artist can depict something that is not actually there. If, for example, you draw a piece of wood and ask someone what they can see, they will reply, 'Wood', whereas, in actual fact, it is only graphite or colour on paper. Mastering this illusion is one of the most important learning goals there is when drawing.

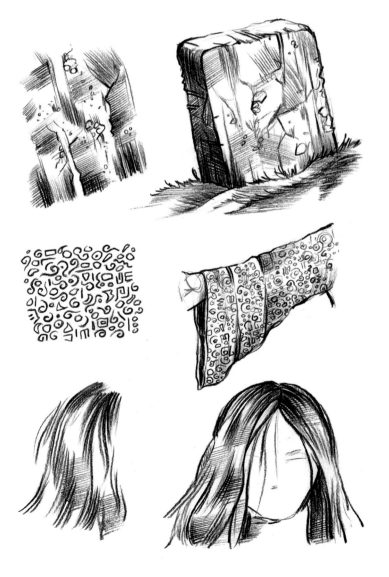

Lots of practice

The pictures show three examples of surfaces that you will need again and again, or at least something similar. On the left-hand side, the material is depicted without any reference to an actual object. On the right-hand side, you can see the same material but incorporated into an object. The following are shown, from top to bottom:

▶ stone
▶ patterned fabric
▶ hair

BASIC COURSE

TIP

Practise these particularly difficult materials and look out for other ones too. There is more information on fabrics and the way they hang on pages 56–57.

11

LIGHT AND SHADE

Light and shade are fundamental in Gothic art. Naturally, the elements of 'shade' and/or 'night', in particular, play a major role, if not the most important role. In order to achieve expressive motifs in spite of the presence of black and dark shading, it is important to employ light in a targeted way, as you will only be able to recognise the darkness where it is contrasted against light.

Working with bright and dark light

Normally, areas that are turned towards the light are bright and areas turned away from the light are dark. However, with this genre, you can also work well with dark light, where everything behaves in completely the opposite way. The picture gives a simple example, with the left-hand side showing dark light and the right-hand side showing white light.

The world in black

In this instance, dark light means that everything that is hit by the light is black and dark, as opposed to being white and bright. Accordingly, the colour of shade is also reversed and appears on dark paper as white.

TIP
When practising the use of light and shade in pictures, it is very helpful to draw a little arrow on the drawing paper to indicate the direction of the light.

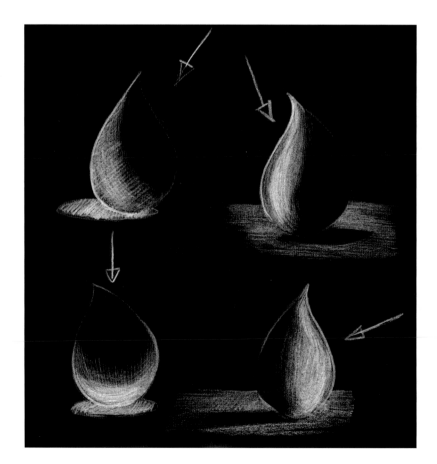

The world in white

In bright light (right-hand side) everything corresponds to what we actually see, i.e. the shade is dark and the areas hit by the light are light.

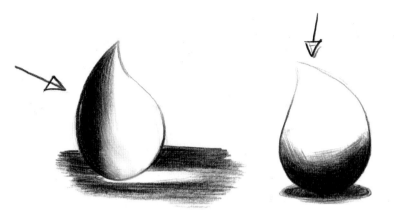

Contrast

Working with contrasts also comes under the heading of 'light and shade'. Every object looks completely different in candlelight as opposed to the bright midday sun. The reason for this is that, depending on how the light falls and how strongly it shines, the light/dark contrast in an object will be different.

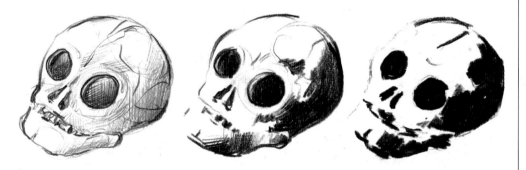

Giving form through contrasts

The picture above shows the various stages of contrast using a skull. In the representation on the left-hand side, you can see soft shading, which has become harder in the middle picture. In the picture on the right-hand side, the motif has been reduced to the stark contrast of black against white.

INFO

CONTRASTS AROUND US

Whereas script usually consists of a stark contrast between black and white, black and white photography is fascinating for its many shades of grey.

13

PERSPECTIVE

Drawing with perspective is something that at first glance appears to be rather serious and functional. However, once you have mastered the basic techniques, undreamt-of possibilities are opened up to you. Perspective plays a significant role in Gothic art, as everything to do with architecture, objects or even accessories is directly connected with it. Perspective can be divided into four different types.

Isometry

This means that all the lines that are opposite one another and that run in the same direction in the imagined or actual object, also run absolutely parallel in the drawing.

One-point perspective

The receding lines all meet at a single point on the horizon. Horizontal lines run parallel to the horizon and are at right angles to all the vertical lines.

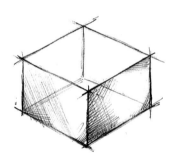

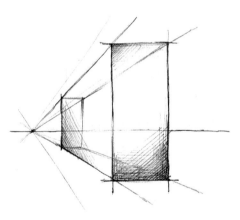

Two-point perspective

All receding lines meet at two points on the horizon. Vertical lines are at right angles to the horizon as with a one-point perspective.

Three-point perspective

Two meeting points are present on the horizon. A meeting point is also clearly present above or below the horizon. All the lines meet at one of these points.

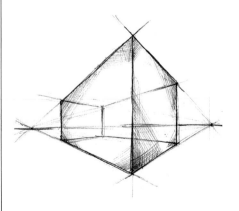

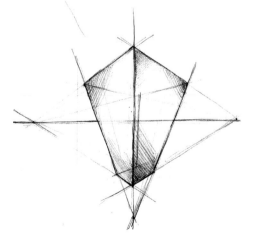

Learning to draw with perspective

Do not use a ruler when practising perspective, otherwise you will not improve. It does not matter if it is not a hundred per cent right. Many famous artists, such as those of the Expressionist movement, deliberately altered the perspective of their pictures to achieve specific effects.

A comparison

Illustrated below you can see two simple uses of perspective in drawings. In the main section of this book, you will find other ways in which this important feature can be used for individual subjects.

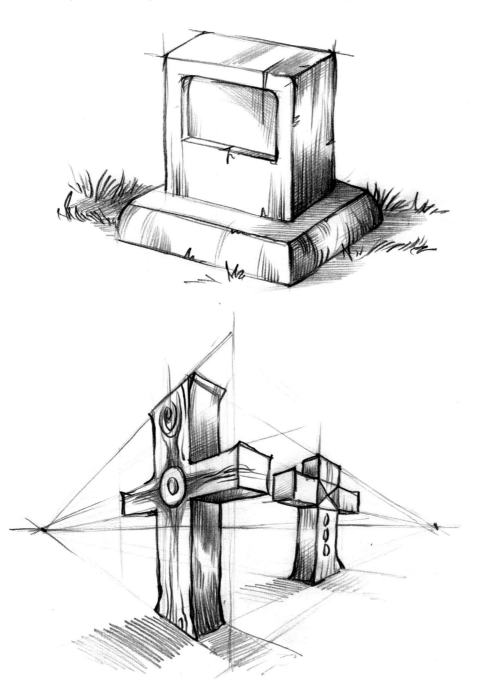

TECHNIQUES

You have now learned the most important techniques for drawing and, with some practice, you can now turn to your first motifs. Before you do this, though, you still have an important decision to make, as there are basically four different ways of drawing with black or white pencils. The pictures show these techniques using a drawing of an eye.

Pencil and white paper 1

This is the portrayal that you will see most frequently. A pencil is used to draw on white paper, which means that dark areas have been depicted simply by using stronger pressure to create dark surfaces.

White pencil and black paper 1

As on the left, this is a realistic portrayal of an eye. Here a white pencil has been used to draw on black paper, so it is necessary to leave blank all the dark areas on the paper and not to draw over them. Mistakes can be corrected by drawing over the white areas using a black coloured pencil.

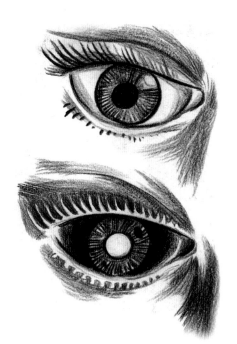

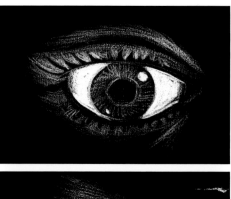

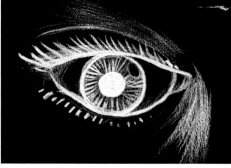

Pencil and white paper 2

This version is the most unusual one. Technically, it corresponds with the picture shown top right. However, it is very unusual to employ this method on white paper.

White pencil and black paper 2

This version basically corresponds to the technique shown top left, except that here a white pencil has been used to draw on black paper. This means that everything is optically reversed and that everything that would normally be dark is now light.

ART IN EVERYDAY LIFE

Within the Goth scene, it is actually a contradiction to talk about fashion, as one of the most important concerns of the scene is to distance itself from short-lived, commercial fashion trends. Nevertheless, there are stylistic devices that give expression to its philosophy of life.

Make-up

The formation of the eyes is particularly significant, as they are the best way of expressing melancholy. Below are some examples. Black eyeliner and mascara, as well as special contact lenses, achieve a particular look.

TIP

Eyes are pretty much essential for human communication and that is why striking eye make-up is always noticed.

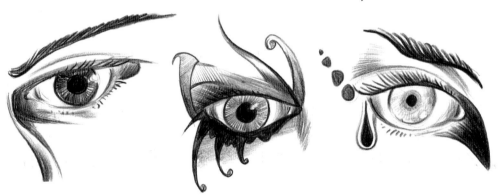

Use of forms and designs

As well as portraying simple symbols, you can now develop some of your own designs with the help of the techniques learned in the basic course. There are no limits to your creativity. You will find some examples below.

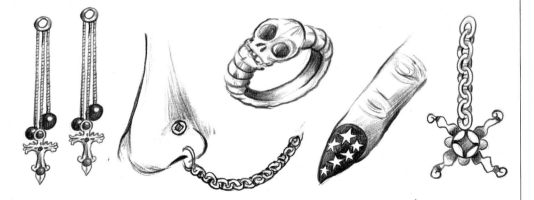

TIP

You will find further ideas for creating impressive make-up on pages 38–39.

BASIC COURSE

PEOPLE

In the history of art there are countless portrayals of human figures and in Gothic art, too, people play a significant role. That is why in the motif section of the book, from page 22 onwards, you will find not only faces, but also pictures of men and women that have either been inspired by the scene or could have come from a Gothic fantasy.

Anatomy

Human anatomy is a very big subject and if you want to learn about it in depth, you will find numerous publications on the subject. We are therefore going to focus here solely on the most important basic knowledge.

INFO
USEFUL MODELS

Manikins are small, simplified, wooden figures with moveable limbs. Their proportions correspond with those of a human and the limbs are attached in such a way that they can make most movements.

Body language

A simple manikin can be very helpful for capturing the human form through drawing. Sit a manikin on the table and try to copy the movement portrayed using just a few strokes. Draw the joints as small circles. This will make depicting specific poses easier.

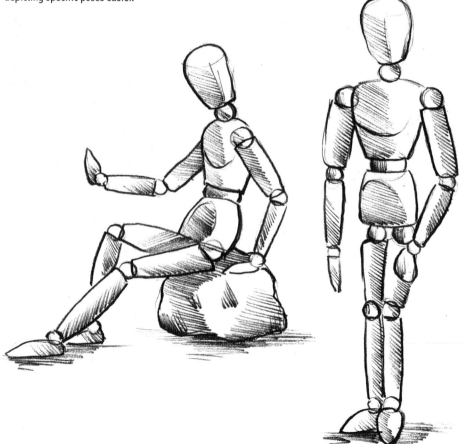

Freehand drawing

Once you feel more confident, then you can move on to freehand drawing by using what you have learned to make simple sketches of figures using just a few strokes. Once you have learned this technique and the proportions of the human body, you will have made significant progress.

Here are some important body proportions that you should always have to hand when drawing humans or figures similar to humans:

▸ The size of the head of an adult corresponds to roughly one seventh of the total body size.

▸ The hips divide the upper body and the legs roughly in a ratio of 1:1.

▸ The tips of the outstretched fingers on hanging arms end roughly at the middle of the thighs.

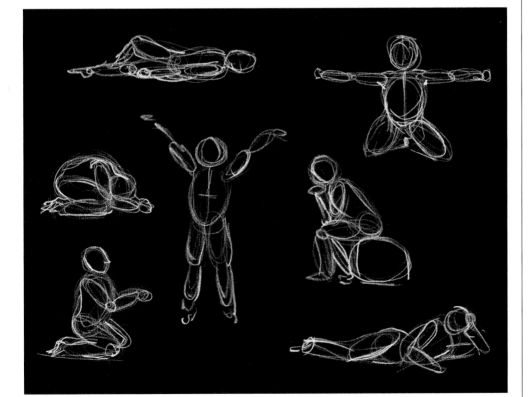

PORTRAITS

Whether you want to draw faces for portraits or whether you initially just want to try out on paper the effect of a particular style of make-up (that you will then use as a template), drawing this expressive face is an artistic challenge.

Black ...

Black, like white and red, is one of the oldest colours of all. It was used by cave painters as long ago as the Stone Age for their rituals and immortal paintings. It gives any face no end of vivacity and charisma and is far and away the best means of creating a face that sends a very definite message.

... and white

Nowhere else does black look as fantastic as it does on white. White-painted faces come from an ideal of beauty that dates from the Middle Ages, when brown skin was a characteristic of simple folk who spent all day working outside in the fields. Fine, pale skin was a feature of the aristocratic nobility, who were protected within their castles. Followers of the Goth scene also often have naturally pale skin as lying in the blazing midday sun does not fit with their way of life. Nowadays, with increasing exposure to UV radiation from the sun, this is certainly not an unhealthy principle.

INFO
INSPIRATION

In African art, too, faces have been depicted in black and white in pictures of celebrations, rituals, war or hunting. See if you can find some pictures or make a study of masks. You will definitely find some ideas that will give you inspiration.

When drawing a head, some simple, basic rules should be followed. The diagrams on the right show a stylised head in different positions.

► In the frontal view, two guidelines are drawn in, one vertical, the other horizontal. These lines divide the head into two equal oval halves.

► The eyes are positioned on the horizontal line, i.e. almost exactly in the middle of the face.

► Note exactly how the guidelines become curved when the perspective is altered and give the new positions of the individual features.

WORKSHOP TIPS

On the following pages, you will see how different individual expressions can be, even though each one is only created in black and white.

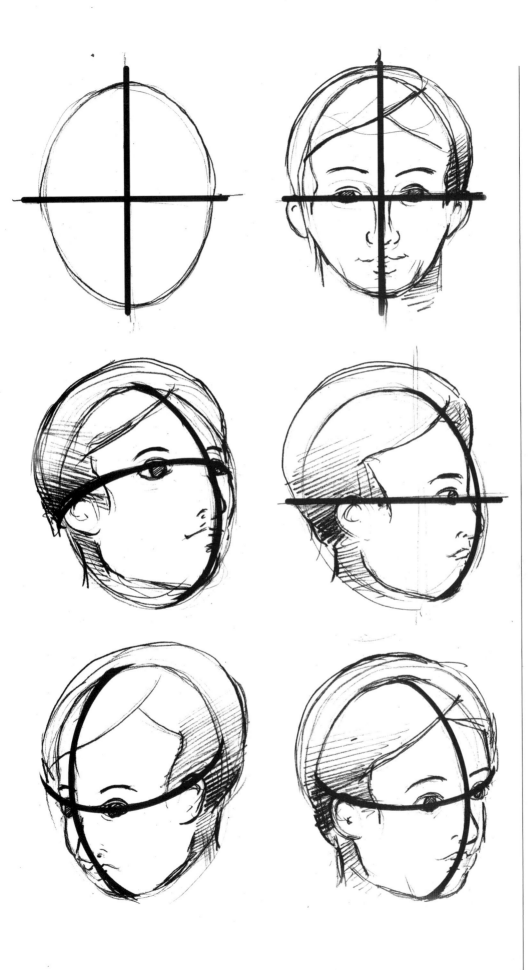

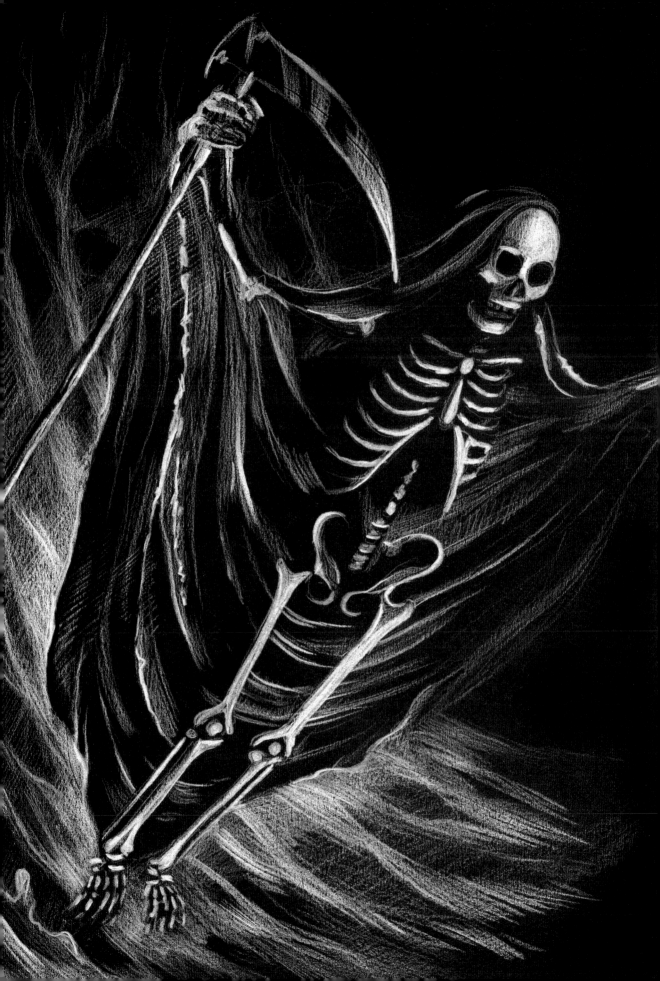

INFO

SKULLS

Although symbols such as skulls have always been associated with the rock scene, the rock and Goth scenes have nothing in common.

SIGNS & SYMBOLS

Every trend within the Goth scene has its own signs and symbols. Their origins are often very varied – from ancient codes pre-dating Christ, through to independent designs that are based upon religious or heathen symbols.

These symbols, often relating to death, make the scene seem even more mystical and set it

SYMBOLS

The very specific language of symbols associated with the Goth scene manifests itself through jewellery and other accessories. Not only do they reflect the Goths' predilection for gloominess, but they are also an expression of individual creativity. Anyone is free to create their own world from the many different Goth symbols that exist.

Spiritual sources

Many Goths are interested in the ancient and current religions of the world, as well as in the philosophy of life of heathens. They create their own individual beliefs from these, which they externalise through the wearing of different symbols. There is no uniform approach here, as it is very much down to the individual.

The dark universe

There are, however, some striking stylistic devices that are representative of almost all Gothic trends. These include:

▶ animals such as bats and spiders
▶ religious symbols such as crosses
▶ objects from cemeteries such as gravestones and steles
▶ skulls and skeletons.

Jewellery

Finding suitable jewellery and wearing it to give expression to thoughts, feelings and convictions is one of the main statements of the Goth scene, and arranging such symbols is a main feature of artistic creativity.

TIP

Creating script in connection with a particular symbol is also a basic way of giving it expression.

WORKSHOP TIPS

The diagrams on the right illustrate how you can develop powerful signs and symbols in a simple way.

▶ Linear circular or cross shapes, sometimes combined together, form a basic framework in the diagrams on the right, from which more complex shapes can be developed. For examples, look at:

 ▶ Death cults

 ▶ Literature

 ▶ Fantasies

 ▶ Internet

 ▶ Nature

▶ In the following section of this book, you will find further ideas for creating jewellery, script and symbols.

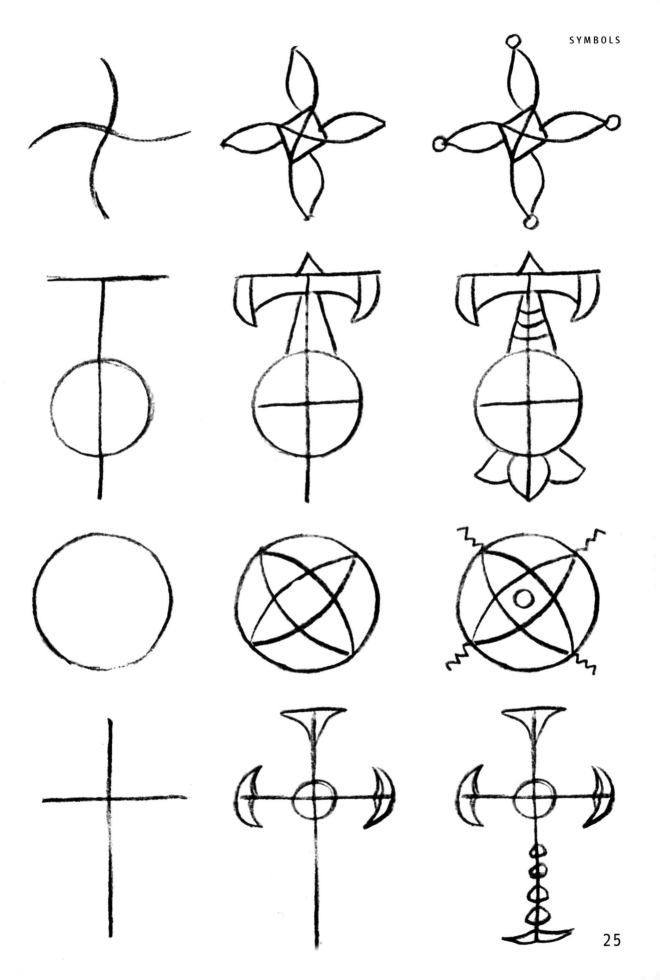

SCRIPT & SYMBOLS

People have been using signs and pictures to communicate messages for tens of thousands of years. Every message is more than just a record of syllables and words, and deciphering ancient script or developing new (secret) languages is one of the most satisfying tasks for the human spirit.

LEVEL OF DIFFICULTY

TIME REQUIRED

Approx. 60 minutes

MATERIALS

- soft white coloured pencils
- soft black coloured pencils
- pencil for guidelines, if necessary
- grey paper

Special features of the motif

The aim of this classic design study is to develop a striking style of script, for example for a website or a T-shirt, and to arrange symbols around this script that harmonise with one another.

How to form the motif

Using very fine, grey strokes, which can no longer be seen here, start out by drawing in some guidelines to help you with your work.

1 Take a white coloured pencil and try to position the script and the symbols on the paper using just a few strokes.

2 Accentuate the script around the upper edges of the letters with the white coloured pencil, by making the contours here significantly thicker. Proceed in the same way with the symbols.

INFO

SYMBOLS

Even in the very oldest paintings of humanity (for example, the rock drawings in the caves of Lascaux and Altamira), signs with magic and symbolic character were being used.

TIP

The first dark areas can now be shaded, using the black coloured pencil.

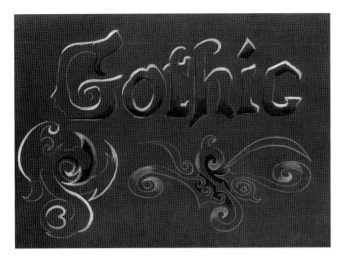

3 Continue working in this way by making individual design elements lighter and darker.

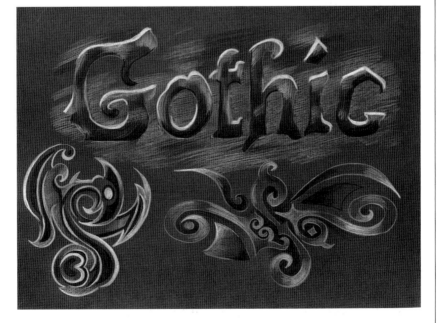

4 Add new interest to the dragon-like design, bottom left, through further shaded areas and structures within the motif.

5 Carry on with the detailed work until it is complete, but do not overload the motifs, as part of their attraction is a certain simplicity.

TIP

Fine, white shading makes the elements appear more three-dimensional.

DETAIL

By broadly shading around the edges of the script, you can link it into the background.

27

SCRIPT

In order to create a script that really means something to you, you will need to play around with various types. As an alternative to the Gothic script on pages 26–27, here are two interesting examples for use on white paper.

Special features of the motif

Both these scripts can be used in a variety of ways. In step 5, you will see how, by adding further symbols, you can give a script additional visual character.

LEVEL OF DIFFICULTY

TIME REQUIRED
Approx. 40 minutes

MATERIALS
◆ white pencil
◆ black coloured pencil
◆ white paper

TIP
Make sure that the two types of script are very different, so that you have a selection to use later.

1 Using a pencil, start by outlining the rough shapes on paper. A regular pencil has an advantage over a coloured pencil in that you can still easily erase the lines.

2 Some heavy shading using the black coloured pencil starts to give the motifs a strong look. In the top motif, a more graphical shading technique is used with straight lines, while in the lower script, the lines are somewhat freer.

3 Give your imagination free rein and continue to develop the shading. The bottom motif lends itself particularly well to playing around with shapes and symbols.

4 The top motif is now almost finished. Carefully shade to highlight the three-dimensional nature and the powerful impact of the letters. The bottom motif is complemented by plant-like formations and elements.

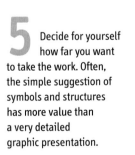

5 Decide for yourself how far you want to take the work. Often, the simple suggestion of symbols and structures has more value than a very detailed graphic presentation.

INFO

SCRIPT

We start to talk about script when there is a definite and reproducible system behind the signs. Geometric lines were used as long ago as the Neolithic age and were presumably used for numerical calculations.

VARIATIONS

The motifs can also be very impressive when they are drawn on black paper using a white pen.

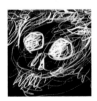

JEWELLERY

Making designs for jewellery is one of the most enjoyable ways of being creative. On page 25, the steps have been set out in detail. By following the drawings here, you can see the exact graphic composition of three designs.

Special features of the motif

Once the design is ready, you only need to decide whether to use a goldsmith or a silversmith to translate the design into an actual piece of jewellery.

LEVEL OF DIFFICULTY

TIME REQUIRED
Approx. 50 minutes

MATERIALS
◆ soft white coloured pencil
◆ black paper

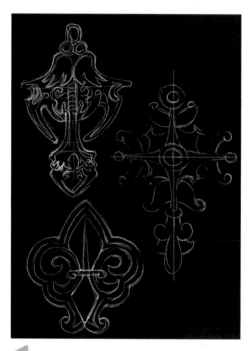

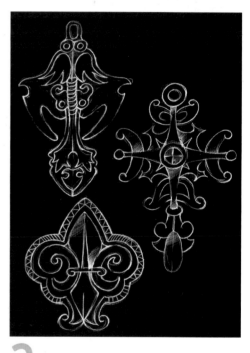

1 Design a basic framework using fine guidelines and build on this with individual design elements.

2 Refine your design and add further details to it.

TIP
The more difficult the composition of a piece of jewellery, the more you should initially use guidelines for your work.

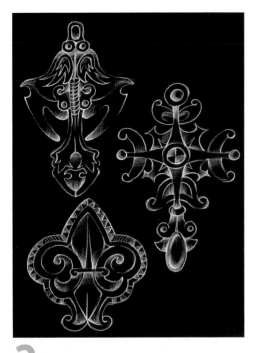

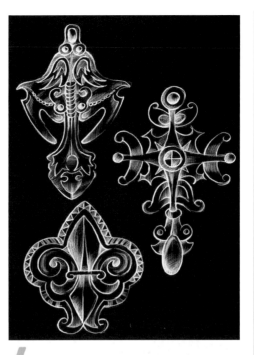

3 You can now make certain areas of the drawing really stand out by using light shading. This will give the motifs more of a three-dimensional effect and greater expressiveness.

4 Continue to develop your drawings, allowing yourself to be inspired by new ideas and details.

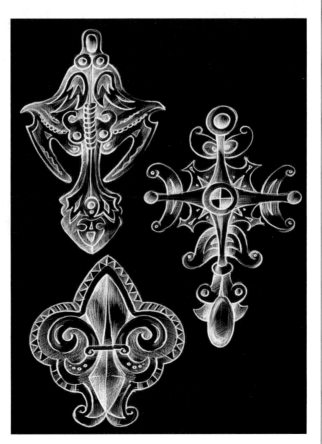

5 You can keep on adding new design elements and building on them until you feel they are complete.

VARIATIONS

If you find it easier to work with a pencil on white paper, you can of course draw your designs that way too.

DECORATION

An impressive, personal decoration can be used in a variety of ways and is not actually all that difficult to develop. You can use it on envelopes as well as T-shirts, or even as a template for a tattoo.

Special features of the motif

Having fun with different figurative symbols and signs is the main purpose of this drawing. They are interwoven in such a way that the final decoration could be suitable for printing on to a T-shirt, for example.

LEVEL OF DIFFICULTY

TIME REQUIRED
Approx. 60 minutes

MATERIALS
- soft pencil
- black coloured pencil
- white paper

TIP
Make sure from the start that you lay out the design on paper so that you are free to then develop the motif.

1 Carefully build up your motif using a pencil. A few guidelines roughly setting out the design will make the work a lot easier.

2 Make your first sketch more precise using a black coloured pencil, by drawing over the contours with clean lines. Using fine, dark shading, define the first of the shaded areas.

3 Carefully work on the motif with further shading. New details, for example the roses, refine the picture further.

4 Be brave and make the shaded areas really black. Gothic motifs work best when you use an expressive combination of light and dark.

TIP

If the intertwined decoration does not work when drawn freehand, you can always trace it from the book.

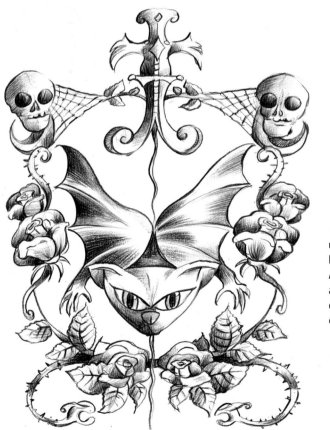

5 Continue with the drawing until it is complete and keep refining the details. Any guidelines that are still visible and detract from the picture can be erased.

DETAIL

This shows how the fine network of the spider's web has been interwoven with the skull.

33

THE GRIM REAPER

Whether a Christian or heathen death cult, all the metaphors and symbols surrounding death are basic components of Gothic art, as is the portrayal of death in the form of a skeleton with cloak and scythe.

LEVEL OF DIFFICULTY

TIME REQUIRED

Approx. 50 minutes

MATERIALS

- soft white coloured pencil
- black paper

Special features of the motif

What is unusual about this representation is that you see the whole skeleton. Usually, this is largely covered by a cloak.

TIP

The best idea is to find a picture (photograph or anatomical representation) of a skeleton and study it well.

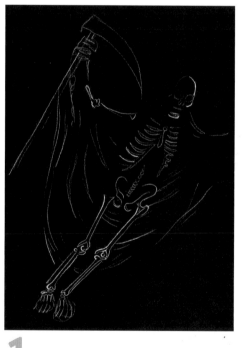

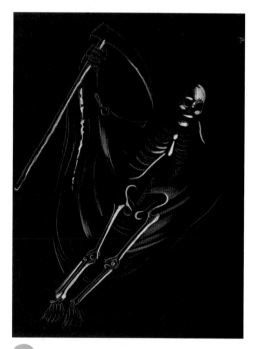

1 In order to reproduce this motif accurately, you will need to master one major challenge – the basic structure.

TIP

With an artistic representation, it is not important to reproduce everything in an anatomically exact manner.

2 Once you have mastered the basic structure, the rest is fairly easy. Fill the individual bones and other parts of the motif with white areas and shading.

34

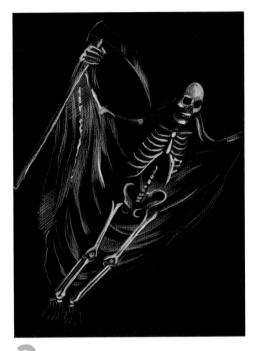

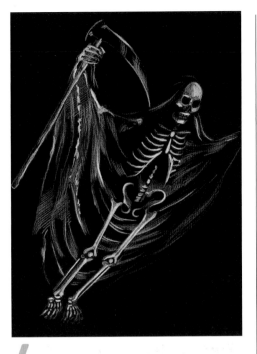

3 Continue with the work, but make sure that you do not have too much white shading. There should always be a strong contrast with the black.

4 It is fairly laborious drawing in the individual bones of the feet and spine, but it is a tedious task that you need to master. Here, too, artistic licence takes precedence over anatomical accuracy.

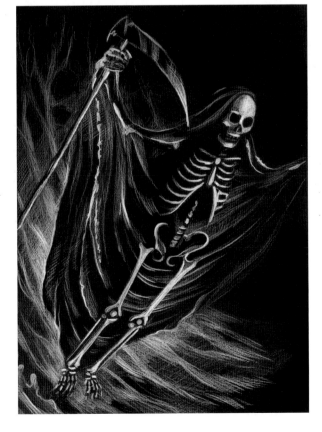

5 When complete, you can also draw an environment from which this angel of death has arisen. Here, a smoke- or cloud-like element has been chosen. There are, however, numerous other possibilities.

DETAIL

You will need some patience for the fine bones of the feet and you may need to use a diagram of a skeleton as a template.

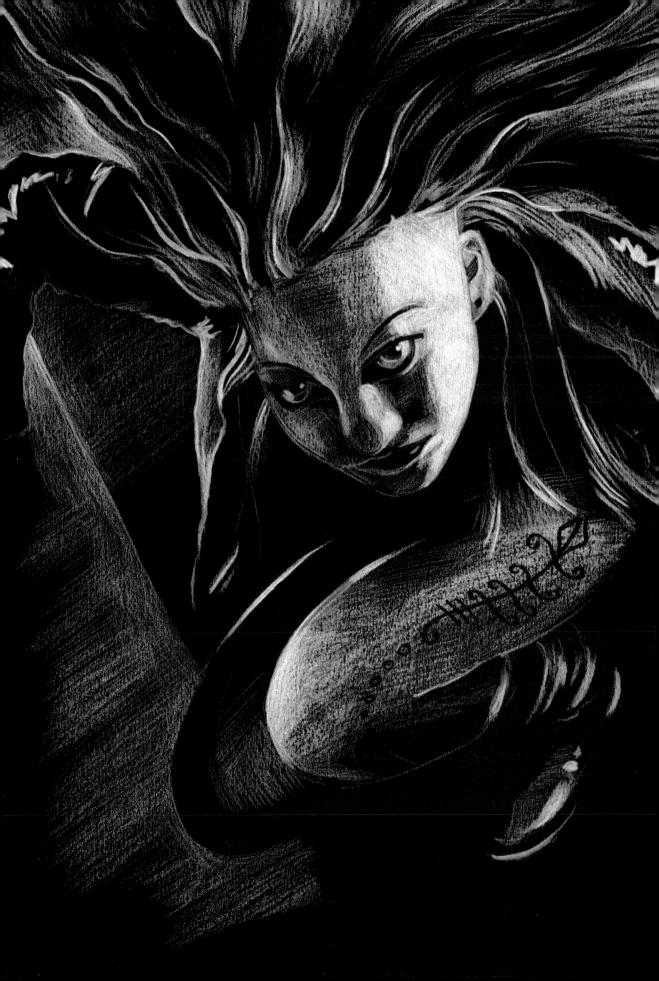

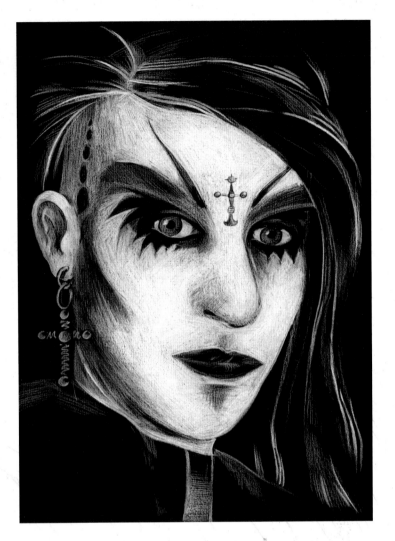

INFO
CONTRASTS
Black clothes and
black hair against
very light skin – this
basic and extremely
powerful contrast
makes drawing
people from the Goth
scene so interesting.

PEOPLE

When compared to the usual faces of people, the striking and creative faces of men and women involved in the Goth scene appear unusual, if not a little frightening. Yet what most people appear to forget is that behind the white painted faces are people who have the right to be accepted as they are. The Goth scene is actually very tolerant in its view of other people, which is why it also expects to be accorded the same degree of tolerance itself.

WILD LOOK

The expressive hair and challenging look say it all: this is a person who has not fitted into the mainstream culture – one who is seeking an individual path, and has the strength to achieve it.

Special features of the motif

To highlight the spontaneity and originality of the expression, a rough drawn sketch was selected. This makes the challenging nature and wildness of the face stand out even more.

LEVEL OF DIFFICULTY

TIME REQUIRED
Approx. 30 minutes

MATERIALS
◆ soft pencil
◆ black chalk
◆ white paper

TIP
If you let yourself become tense when drawing, the picture is more likely to be stiff and unnatural. It is best to approach the subject in a relaxed, confident manner, and use bold strokes.

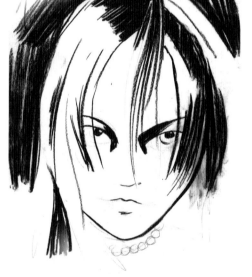

1 First of all, the rough shape of the face is made on paper using the soft pencil. With the black chalk, you can then begin to place the first dark accents in the contours.

2 Fill in the dark areas of the motif using bold strokes.

TIP
Draw quickly, showing the beautiful, wild hair using single strokes.

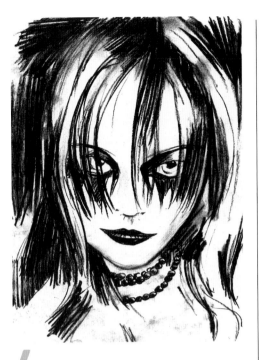

3 Go into a little more detail. Concentrate on the eyes, mouth and individual strands of hair. Even the beaded necklace is an important element of the picture.

4 Continue with the work. When filling the large areas, it is best to place a sheet of paper between your hand and the drawing, to prevent the picture from smudging too much.

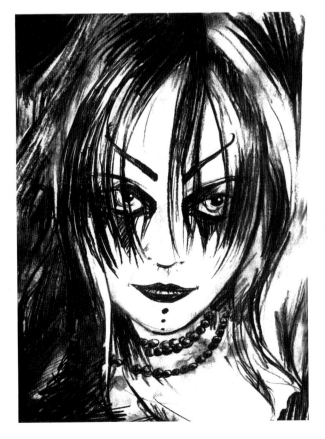

5 At the end, the final details of the face can be drawn in and the finishing touches can be made to the hair.

TIP
Leave sufficient white from the paper showing through, as this will add life to the drawing.

39

BAT MAN

With a classic portrait, the face created by nature must be recreated using artistic means. It has always been important for artists to represent the true personality behind a face. The individual traits in a Gothic face blend in with the character – something that is more unexpected here than with expressionist portraits, and which makes these portraits so unbelievably fascinating.

LEVEL OF DIFFICULTY

TIME REQUIRED

Approx. 60 minutes

MATERIALS

◆ soft white coloured pencil
◆ soft black coloured pencil
◆ black paper

Special features of the motif

This motif shows a classic portrait from the genre. A person defined as a follower of the dark scene stands out in the foreground here. The young man appears serious, self-confident and very aware of his role.

How to form the motif

In order to capture the strength of the face perfectly, the proportions must be in line with the scale. Be aware of this right from the very first strokes in step 1.

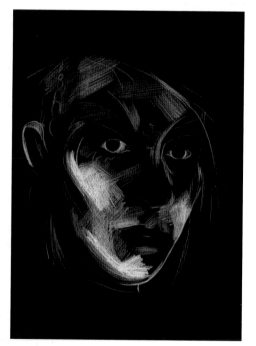

1 With all portraits it is important to make the face anatomically correct from the start.

2 Portray the man's white skin with strong shading.

TIP

Remember not to draw over in white the areas in the picture that are to appear black later on.

40

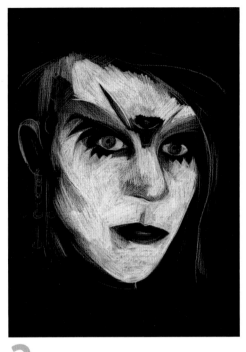

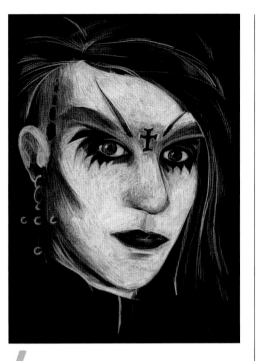

Take care over the shape of the shading around the eyes, which look like bat wings, as well as the cross on the forehead, whose statement is repeated in the earring.

3 Work on the areas of the picture that will later appear grey (such as the cheeks) using less pressure, so that the black of the paper can still shine through.

4 Concentrate on portraying the hair and jewellery.

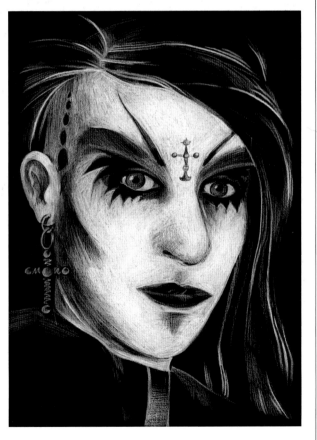

DETAIL

The hair does not need too much work. Just a few strokes are sufficient to create an expressive hairstyle.

5 Finally, draw in the remaining details and correct with a black coloured pencil the parts that you are not so keen on. The portrait is then complete.

TEARS AND SORROW

Art does not always depict happy scenes and pictures. Shocking masterpieces like 'Guernica' by Picasso or the numerous scenes of the burial of Christ show death, violence or suffering as central themes running through our daily lives.

**LEVEL OF
DIFFICULTY**

**TIME
REQUIRED**
Approx. 30 minutes

MATERIALS
- black artist's charcoal
- white paper

Special features of the motif

The portrait of this young woman is characterised by feelings of sorrow and hopelessness. Her deeply sad look, which is reinforced by the black eyeliner around her eyes, reflects the grief that she has suffered.

How to form the motif

The form taken by the shading should be reminiscent of dark tears that surround the eyes like two overflowing pools, with the face appearing to dissolve.

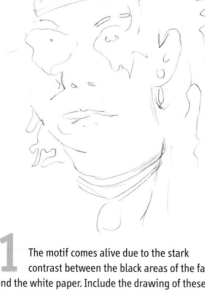

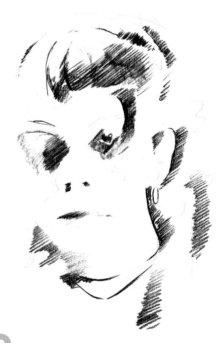

1 The motif comes alive due to the stark contrast between the black areas of the face and the white paper. Include the drawing of these contrasting areas – for example around the eyes – in the basic structure.

2 Start with some strong shading to make the dark shaded areas stand out more. When doing this, always work in the same direction as here: from bottom left to top right.

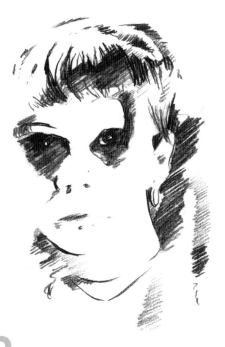

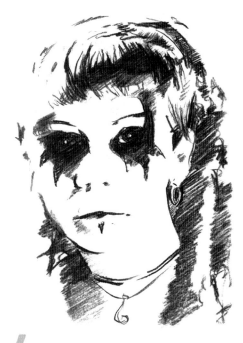

3 Add some strong, black areas to the picture – especially to bring out the expression of the eyes.

4 Continue with this, adding more and more detail. Individual pieces of jewellery, such as chains or earrings, round off the overall impression.

INFO

ARE YOU FAMILIAR WITH THESE?

The works of Baudelaire (1821–1867) are some of the saddest poems in literature.

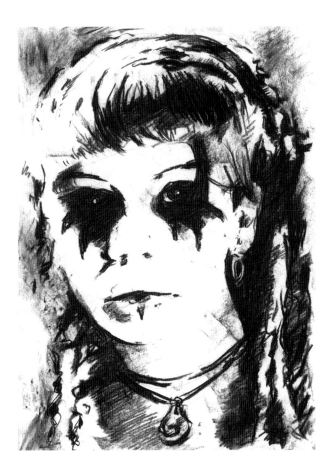

5 Finally, fill in the remaining black areas in order to perfect the contrast.

DETAIL

Some grey, slightly smudged areas at the sides link the motif visually to the background and make the face seem paler.

THE LOOK

To do artistic justice to the unusual, you can simply highlight it, as in the two previous pictures or you can stage-manage it, as in this portrait of a young woman shown from a very unusual perspective.

LEVEL OF DIFFICULTY

TIME REQUIRED

Approx. 60 minutes

MATERIALS

◆ soft white coloured pencils
◆ soft black coloured pencils
◆ black paper

Special features of the motif

In this portrait, you are looking down on the woman from far above and she is bent over, crouching on the ground. In contrast to her position, her look is certainly not obsequious. In fact, she is looking at the observer quite seriously – questioning and with a degree of directness.

How to form the motif

As this motif is extremely ambitious, you should take your time over it, especially in step 2, where it is recommended that you work a little more slowly.

TIP

Hair is one of the best ways of showing a person's true character.

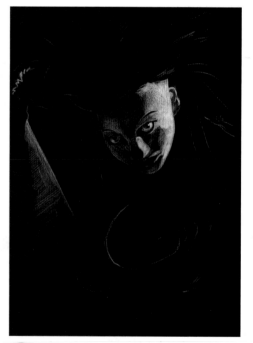

1 If you attempt this motif, you will need to have had some practice in working with unusual perspectives. First, try to convey the basic position using just a few strokes.

2 Fill in the face, with its strong, expressive eyes, using white – make sure that the details remain accurate when portraying the face.

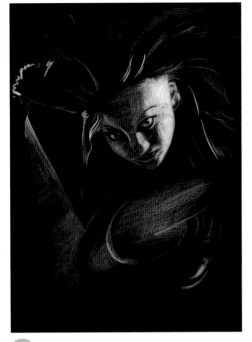

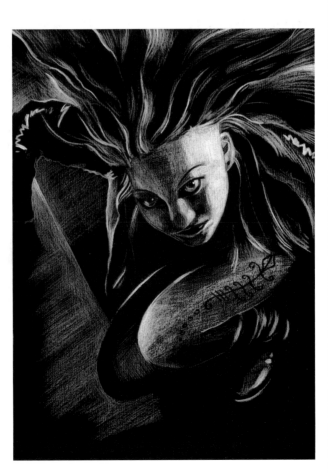

3 Carry on working in this way for the legs, hair and background. Some strong, light accents on the arms give the impression of a black leather or imitation-leather jacket.

4 Concentrate on working on the woman's hair and clothes using further shading.

5 Keep working on the hair until you feel that it is just right. Be careful though: it is better to stop too soon than too late. Adding a few remaining details to the clothing using a black coloured pencil will provide the finishing touches to the drawing. Take a good look at the enlargement of the picture on page 36 as well.

Take a good look at the enlargement of the picture on page 36 as well.

TIP

Particular attention should be given to the hair, as it forms a boundary at the top of the picture in a very expressive, fiery and almost surreal way.

DETAIL

The hair is drawn strand by strand using a white coloured pencil.

MARIONETTE FACE

One of the most exciting jobs in the world of art is that of the mask-creator. In films, on stage or at the pantomime, extreme and bizarre effects can be achieved that become even stronger if, instead of decorating real people, you decorate puppets or create a mask.

LEVEL OF DIFFICULTY

TIME REQUIRED
Approx. 45 minutes

MATERIALS
◆ soft white coloured pencils
◆ black paper

Special features of the motif

This motif is not about creating a portrait of a person. The portrayal is more like a puppet, similar to those found in Tim Burton films.

TIP
Watch one of Tim Burton's masterpieces, such as 'Nightmare before Christmas', and take your inspiration from it.

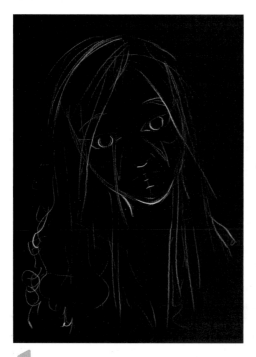

1 The front view of a face is relatively easy to work on, as there are no distortions from a perspective point of view.

TIP
Make sure that the hair is well positioned, as it forms a major part of this picture.

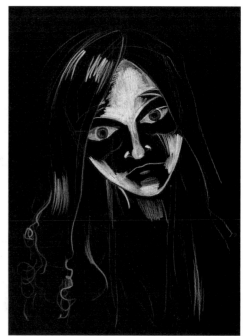

2 Start shading the surface of the face and also draw in the whites of the eyes. Some stronger lines in the hair will help to guide you.

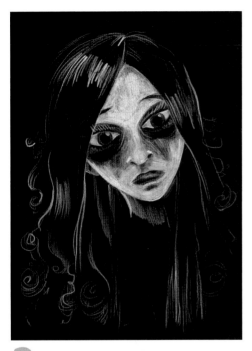

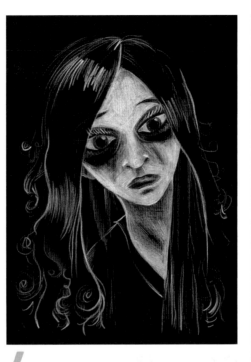

INFO
EXAGGERATION

By graphically exaggerating certain elements, the expression is stronger than that on a real face.

3 The expressiveness of the picture stems directly from the white surface of the face and the linear positioning of the hair. Keep working on the motif in this way.

4 Fill in the neck in the same way as for the face and suggest the clothing.

DETAIL

The stylised curls give the hair an almost decorative character.

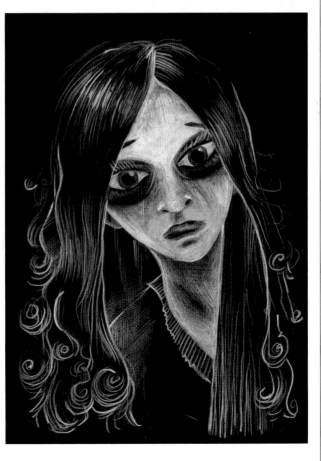

5 Work some more on the clothing and hair. Do not do too much, though, as the face is brought to life from the black that surrounds it.

COLLAGE

This picture is similar to a collage – although nothing is cut out and stuck on. The effect comes from how the meaningful elements (young woman, cross and rose) are arranged without a definite connection.

Special features of the motif

The individual elements of the picture are joined together and interwoven as for a collage. This has the effect of telling a story. A graveyard cross and a sad young woman with a rose in her hand can give rise to many interpretations.

LEVEL OF DIFFICULTY

TIME REQUIRED
Approx. 80 minutes

MATERIALS
- soft white coloured pencils
- soft black coloured pencils
- black paper

TIP
The simplest way of approaching this difficult motif is to break it down first into its individual components.

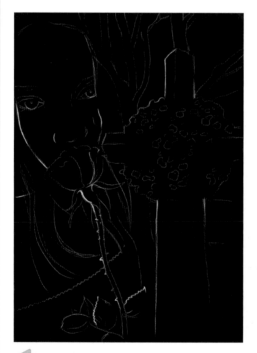

1 Try to get the basic structure of the face, the rose, the cross and the trees next to each other on the paper, using just a few strokes.

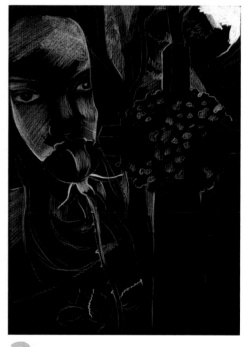

2 When you feel ready, start shading individual areas of the picture.

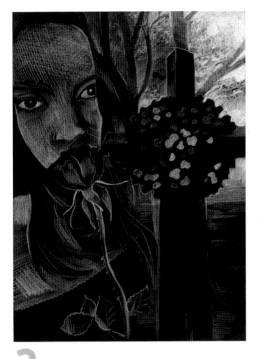

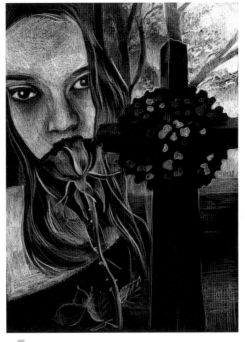

As you build up the picture (after step 2), make sure you interweave the individual elements together from the start.

3 The look on the young woman's face is very significant, so take extra care when drawing the eyes and eyebrows.

4 Now it is time for the details. Work steadily and patiently.

DETAIL

Take time over creating the hair, rose petals and thorns.

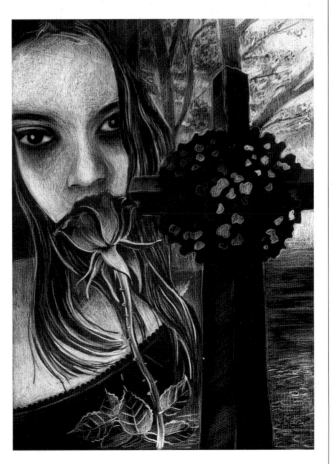

5 At the very end, when you have completed all the light areas, a black coloured pencil will help you to add some more dark accents – for example, around the eyes or in the background around the trees.

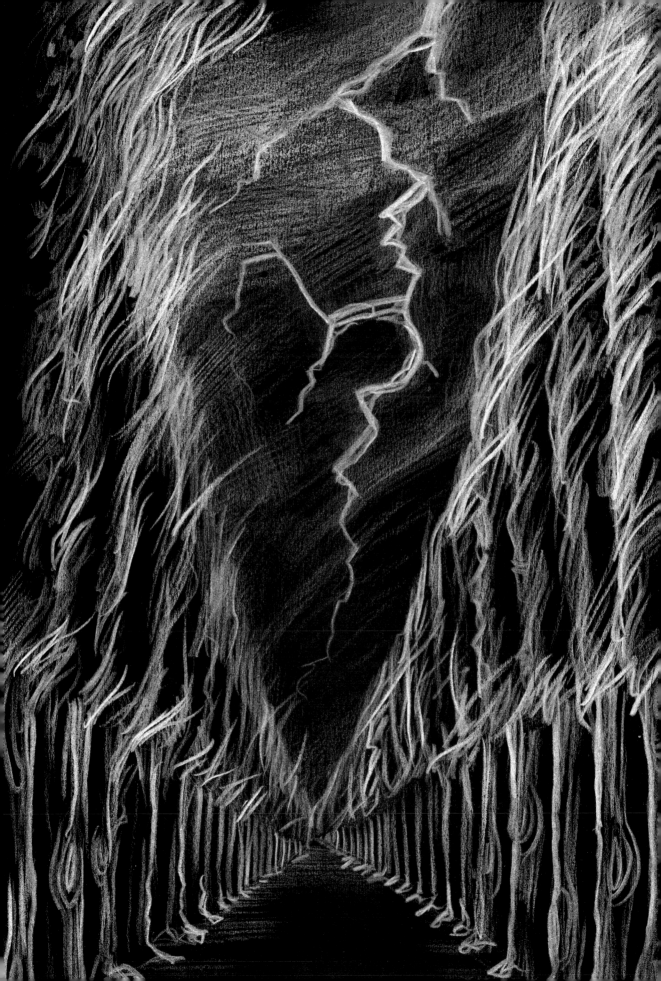

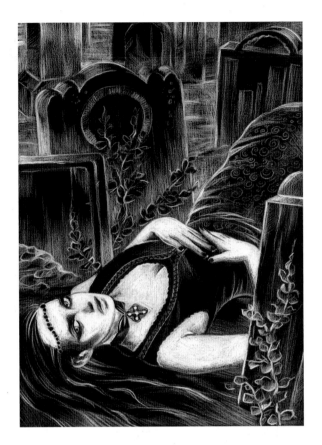

INFO

SILENT CHALLENGE

As the scene itself is too introverted to be self-explanatory, it is up to each individual to discover its true meaning.

POETRY

Rumours often arise out of fear and uncertainty. This applies to the Goth scene too, where followers are often falsely associated with violence, drugs or devil worship. Of course, they have a predilection for all that is dark, secretive or occult – and many followers also have an interest in death. However, their motives run counter to all the rumours and are more concerned with dark poetry, melancholy, art or simply the conscious desire to be different. The following motifs are a window on to the complex levels of feelings within the Goth scene and cover subjects such as death, longing, transitoriness or even romance. Come and undertake this journey and create

PLANTS

Every plant arouses emotions and leads to certain associations, which is why they are essential for adding atmosphere to a scene. It could be a scene at night, a cemetery, an abandoned village or an empty boudoir.

The secret message of plants

Most people know that roses stand for love and that lilies are a symbol of purity and hope. Yet other plants also send messages that are recognised by our subconscious.

▸ Some typical cemetery plants are: yew, chrysanthemum, box, arbor vitae and juniper.

▸ The number three, along with the triangle, stands for the Holy Trinity. The leaf-shape of the ivy reflects this.

▸ Trees with hanging branches, such as aspen, birch or elm and, of course, the weeping willow, remind us of mourning and grief.

▸ Grasses are a sign of transitoriness.

▸ A rose bush stands for protection against evil; the birch is a symbol of life, beginnings and light.

▸ Open flowers are considered in Christianity as signs for the saving of souls and scented flowers, such as lily of the valley, roses and lilies, stand for the promises of Paradise.

WORKSHOP TIPS

The picture on the right, with the rose on the left-hand side, is a nice illustration of how to create the basic structure of a plant and from there to make the complete drawing.

▸ It is important first to emphasise the rough proportions using a few strokes, before going into detail.

▸ In the following examples, you will find further ideas for creating motifs with flowers or other plants.

Botanically correct

Just as, when drawing people, the anatomical accuracy of the form is important for the credibility of the figure; you need to understand the basic structure of a flower or tree to be able to replicate it convincingly.

TIP

This subject, too, is covered in several specialist books, where you will find numerous ideas and technical tricks.

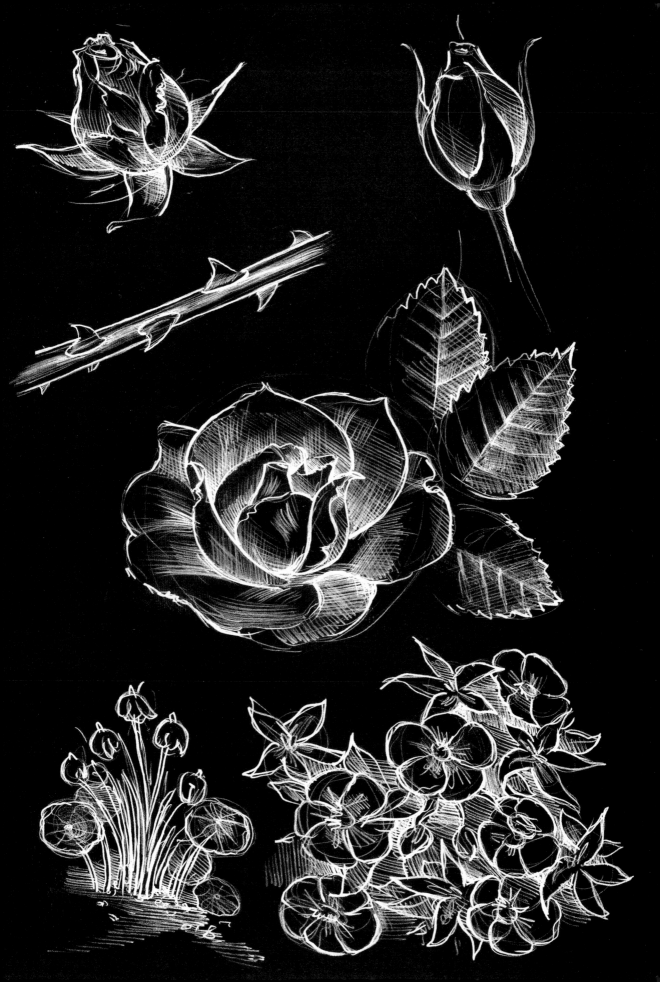

AVENUE IN A THUNDERSTORM

This depiction is unusual, as there are no people in the picture. Nevertheless, an avenue of trees that disappear on the horizon, shown during a thunderstorm, is strongly symbolic. The interpretation of the motif is, however, up to each individual.

Special features of the motif

Anything could happen or could have happened on this lonely road. The atmosphere of the thunderstorm appeals to our imagination like a theatre set, inviting us to invent scenes and stories.

How to form the motif

Read through the important ground rules on perspective on pages 14–15 again. Sketch the motif roughly first.

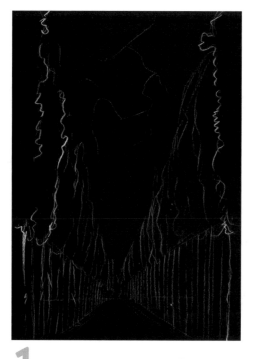

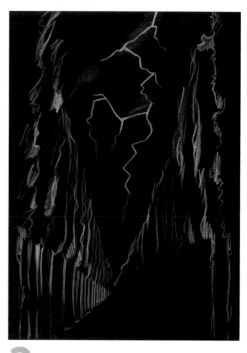

1 The rows of trees meet at a central point on the horizon, creating the appearance of the avenue between them (pages 14–15).

2 Draw the lightning in strongly. Its light illuminates the insides of the trees, represented by strong, white strokes.

LEVEL OF DIFFICULTY

TIME REQUIRED

Approx. 30 minutes

MATERIALS

- soft white coloured pencils
- black coloured pencil
- black paper

TIP

Take the basic structure of the motif from the perspective section in the basic course.

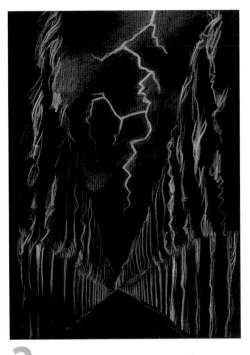

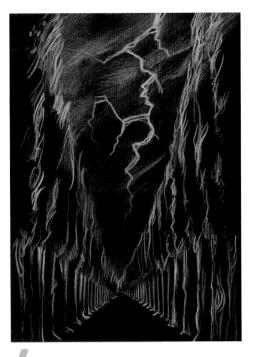

INFO

BIZARRE

When we think of avenues, we usually think of deciduous trees. In Tuscany, tall pines create similar scenes.

3 Continue working on the light/dark contrasts for the trees. Refine the scene in the sky too – making the lightning 'shine' by using fine shading.

4 Draw in the roots around the trunks of the trees to give them support and continue with the work started in step 3.

DETAIL

The roots of the trees grow in the direction of the empty road.

5 At the end, add some more strong lines to the picture that run from bottom left to top right, to give the impression that the trees are being lashed by the storm. This will give the feel of a real thunderstorm.

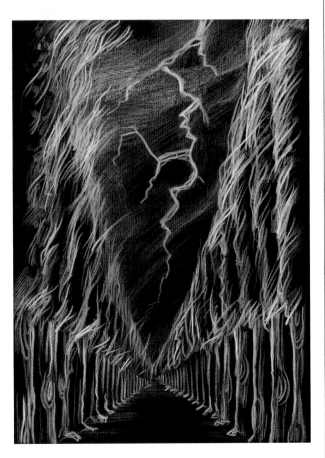

FOLDS IN FABRIC

Creating textiles

It requires some ability to draw textiles. Just reproducing the pattern and weave of a fabric alone takes a degree of technical skill. It is even more difficult to capture and reproduce accurately the fall of individual lengths of fabric and especially the hanging of folds.

WORKSHOP TIPS

There is no substitute for your own observation and for practice when it comes to this subject.

▶ Lay out a piece of fabric in such a way that you can study it in detail.

▶ Try drawing a coat hanging on a hanger.

▶ Try to study and draw the hanging of folds on a live model too.

It is important to notice where the areas of light and shade are. It is a good idea to draw the intended object under different light sources. For example, you could use a standard lamp to shine light on to the folds from different directions. You will be amazed at how different the fabric can look when you do this.

Real-life example

On the right, you can see some very good practice examples that will greatly help you with the complex motifs on the following pages. They are also good for helping you make your own designs for clothing.

▶ Develop an eye for the weave and the hang of different fabrics. The better you know linen, wool, silk, cotton or synthetic fibres, the easier it will be to draw them convincingly.

▶ On the left-hand side, you will see (from top to bottom) wool, cotton, velvet and linen.

▶ On the right-hand side, there are some folds in fabric that show how light and shade bring the folds to life.

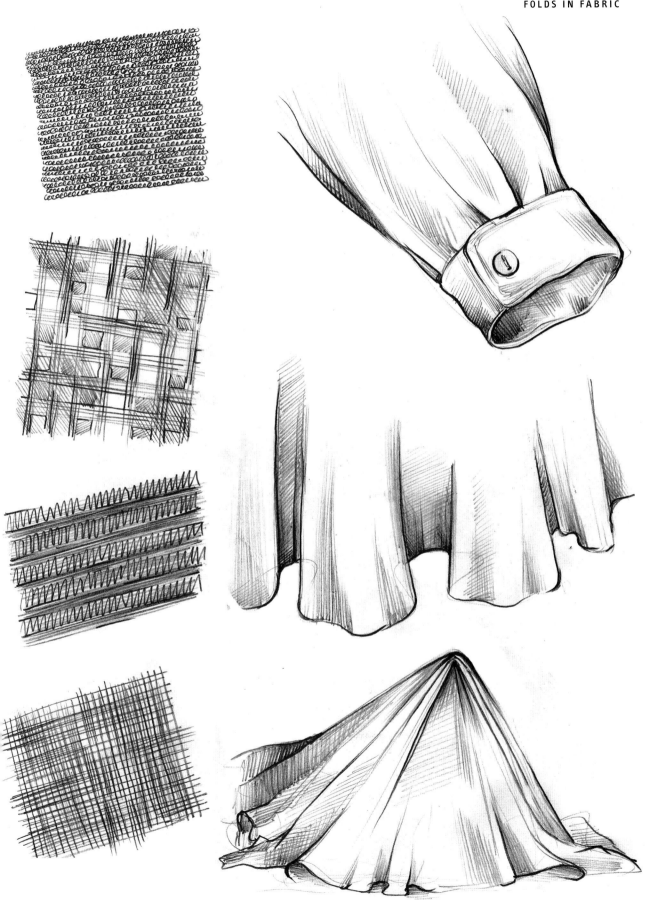

WOMAN WITH STATUE

At first glance, you are only aware of a pretty, young, vivacious woman in the foreground and a statue in the background that reminds you of a graveyard figure. Why is this picture so fascinating that you want to spend more time looking at it?

Special features of the motif

Several contrasts in content clash with one another here: there is the unclear connection between the woman, made of flesh and blood, and the cool stone. The subliminal religious theme is also obvious. You might ask yourself, 'What has the spiritually heathen, almost wild face of the woman to do with the silent, religious appearance of the other figure?'

How to form the motif

The picture is based on contrasts. Focus on working in detail on the figures, with the Gothic arched window in the background, so that they clearly stand out from the black of the dress.

LEVEL OF DIFFICULTY

TIME REQUIRED
Approx. 60 minutes

MATERIALS
◆ soft white coloured pencils
◆ black paper

TIP
Plan the layout of your sheet accurately and use guidelines.

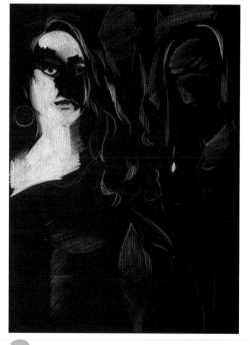

1 In a picture of this kind, it is important right from the start to create an ordered structure for the overall picture.

2 The light areas of the picture are highlighted with some initial strong shading. The background is included in the composition at the same time, and is worked on using finer shading.

3 Continue with this work and model the details of the figure in the background step by step.

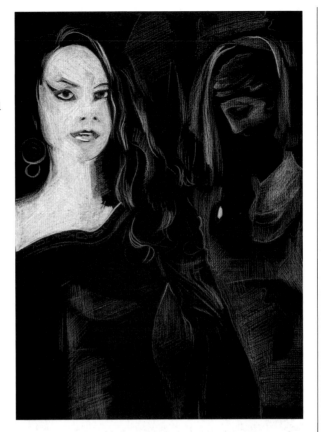

INFO
OPPOSITES
When such strong opposites are united in a picture, as here, the motif acquires a perceptible element of suspense as well as depth.

4 Create the surface of the woman's gown, using fine pencil strokes to fill the area. Form the hair using a few strong lines.

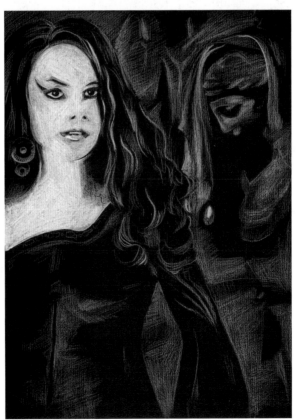

5 To finish working on the motif, draw the piece of jewellery around the neck, the lace edging around the neckline of the dress, the hair accessories and the final artistic details in the eye make-up.

DETAIL

Make sure that you portray the face of the statue in detail. It is the secret centre of the picture.

TIP

This picture is one of the most difficult in the book, but if you have practised carefully all the techniques in the basic course, you should be able to master it.

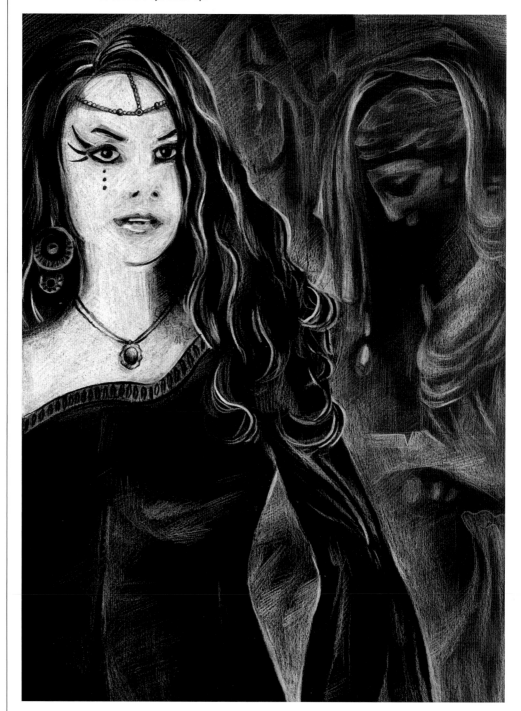

CEMETERY IMAGE

This powerful scene combines it all – the use of perspective for the gravestones, a difficult figure, plants, jewellery and the natural qualities of the materials.

Special features of the motif

The picture has a classic structure with a foreground, a background and a middle. Take care when dividing up the space in step 1 to ensure that the large gravestone and the hair are in the foreground, the young woman is in the middle and the other gravestones are in the background.

LEVEL OF DIFFICULTY

TIME REQUIRED
Approx. 80 minutes

MATERIALS
◆ soft white coloured pencils
◆ black paper

1 Following the design, draw the basic structure using a few well-placed strokes.

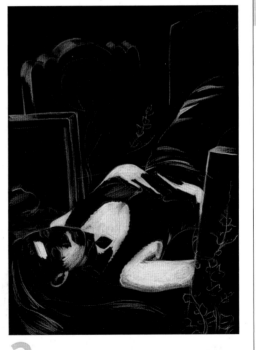

2 Refine the structure of your picture and work to bring out the light elements using some initial strong and light shading.

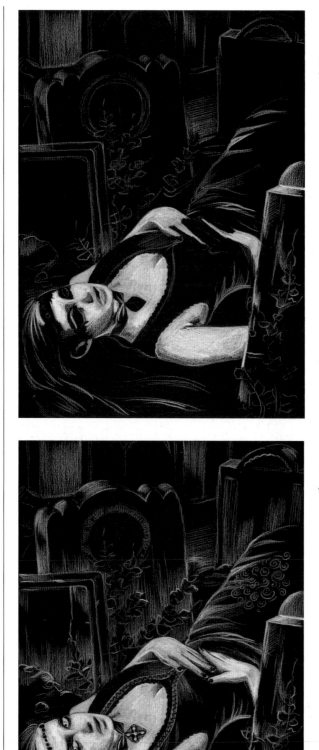

3 Go into greater detail when reproducing the gravestones and plants. The fall of the hair should also be worked upon further.

4 Apply all your skill to the fine, detailed work of the face and the jewellery.

62

5 Work on each element of the picture in detail until it is complete. The fine pattern of the fabric and a clean finish to the plants add the finishing touches to the picture.

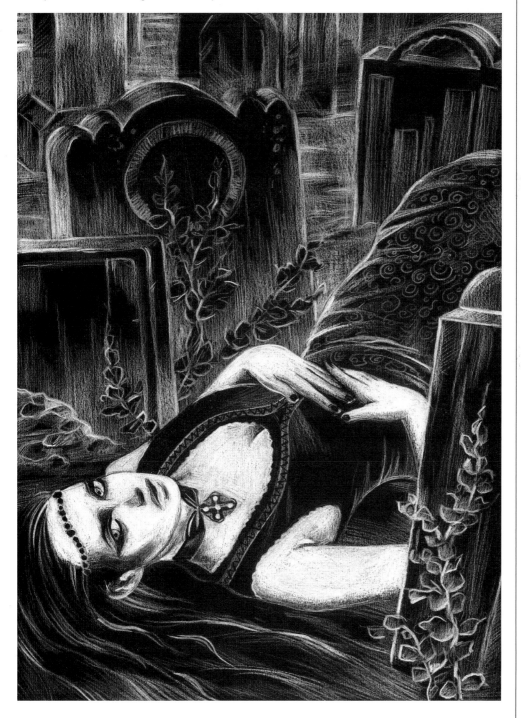

DETAIL

Work carefully when portraying the face.

TIP

The hair looks like a river flowing out to the bottom right of the picture. This association is intended and you should emphasise this impression through the use of wavy lines.

MOONSTRUCK

The picture is one of only a few in the book that does not depict a scene from the real world. This is a picture of a winged elfin girl, who is turning towards the moon with her eyes closed in front of an archway.

Special features of the motif

One particular detail points to the actual dynamic of this scene: while turning towards the moonlight, the girl is at the same time trying to protect herself from the bright light of the full moon – as if it were too dazzling.

LEVEL OF DIFFICULTY

TIME REQUIRED
Approx. 60 minutes

MATERIALS
- soft white coloured pencils
- soft black coloured pencils
- black paper

1 This picture is divided into two: the girl in the foreground and the moon scene in the background.

TIP
Lay out the initial drawing to utilise the space well.

TIP
Carefully build up the foreground and background for the scene as in step 1. You only need to use a few lines.

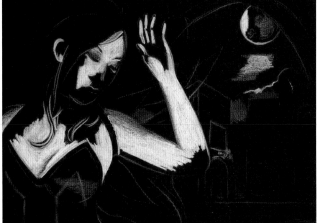

2 Important details are the girl's white skin and the very bright moon. Fill in both of these areas completely with white.

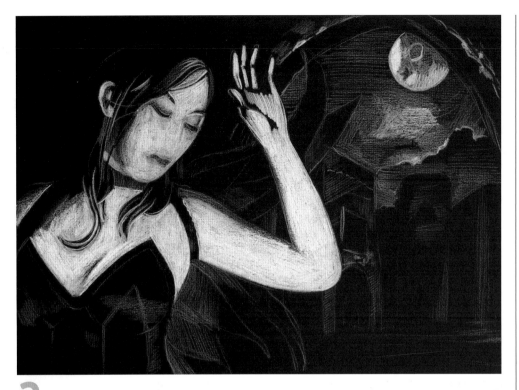

INFO

CREATING MOOD

As people are very sensitive to hidden messages, you should think carefully about the hidden content when drawing, so that you can experience the mood when looking at the picture.

3 Start by creating the background and accentuate the girl's wings with some initial fine shading.

4 Continue with this work until you are happy with how the background looks. Remember that the full moon will bathe the castle, ground and sky in a bright light.

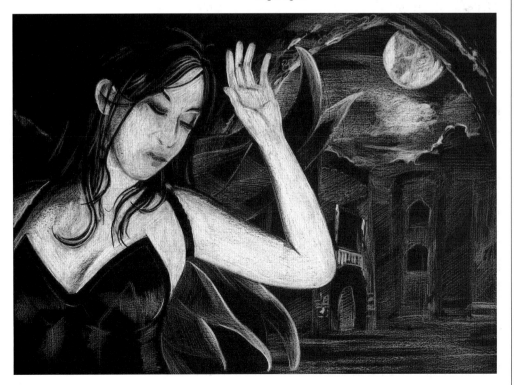

Step 5 is shown here large and clear, so that you can carefully observe all the details and make adjustments to your picture if necessary.

TIP
This picture stands and falls by the expression on the girl's face. Try to replicate the half-asleep, turned-inward expression.

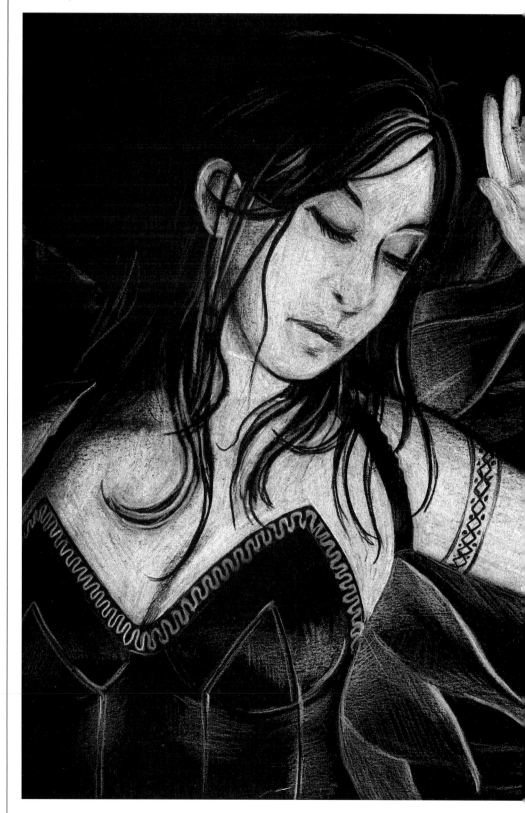

5 At the end, improve the appearance of the picture with some decorative details on the dress. Using a sharp, black coloured pencil, you can refine the expression on the face even more.

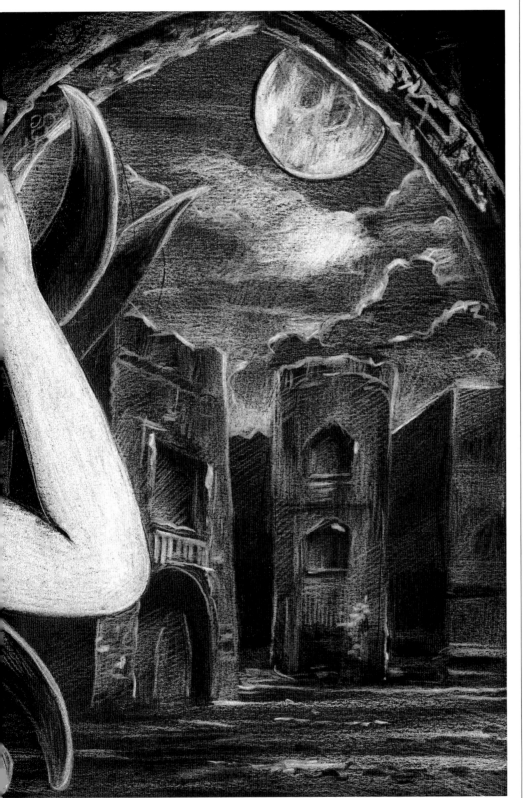

DETAIL

Have you noticed the mysterious tattooed bangle on the girl's arm? You should create this as a final step.

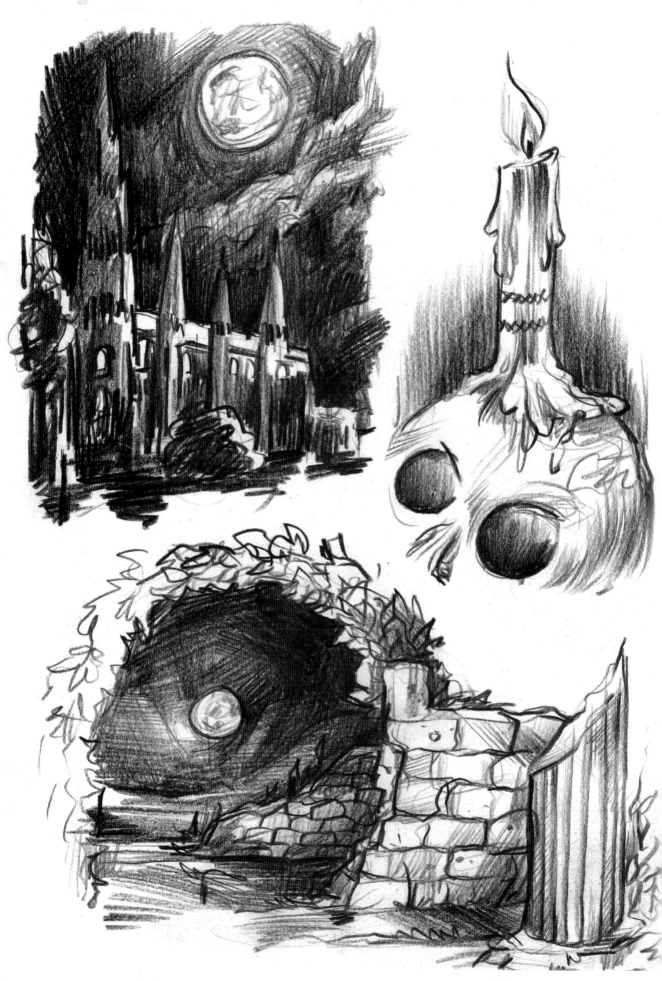

The greatest challenge for a Gothic artist is to bring out his or her own deepest thoughts and ideas in pictures or poems, and to get these down on paper, so that the dark side that is in all of us continues to live on. That is why this section of the book, the actual workshop, will take you a bit further than the basic course and the motif section. This part is about transforming the special viewpoint of Goth culture into Gothic art. You will learn about sources of inspiration and a method that will enable you to draw your own motifs and to develop your own style in doing so. The main thing is to transform the external, colourful world into the dark, melancholic night-time of the poetic worlds.

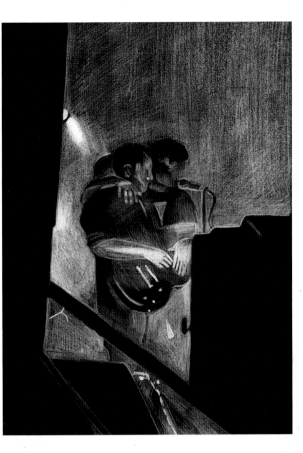

LEARNING OBJECTIVES

▶ Picking the right subject is the first and most important decision that you have to make. From page 70 onwards, you will learn what you need to be aware of when choosing a picture.

▶ An important question is whether a subject can be translated into Gothic style. You will find information on this and how you can approach the picture in an artistic way from page 72 onwards.

▶ The first hurdle when drawing a picture is how to transfer the basic structure of the subject on to paper. As well as freehand drawing, for which you need to have had a little practice, there are other tricks. The possibilities are listed from page 74 onwards.

SELECTING THE RIGHT SUBJECT

People, landscapes, decorations and symbols all have their place in the great world of Gothic art. Everything has its meaning and can be transferred into the dark world accordingly.

Discovering subjects

When designing script and jewellery you can be completely creative and think up new designs yourself, but it is more usual for landscapes or portraits to make use of real images. If you do not feel confident about using a live model or going out into nature, you can find photographs to use as a basis. You just have to find the right ones.

The tower

This photograph shows an old tower on the Mediterranean island of Giglio. This is an ordinary holiday snap that anyone might take.

THE INSPIRATION: Giglio is a place with a particular history and atmosphere. This tiny rocky island has just 2,500 inhabitants and has retained its original wild character despite natural and human influences. In the narrow alleyways of Giglio Castello, the fortress-like village at the top of the mountain, the Middle Ages still seem to live on, especially on the many days when the mist shrouds the streets. The whole atmosphere of the island and the almighty power of the castle are attractive enough to be able to make an artistic motif from this.

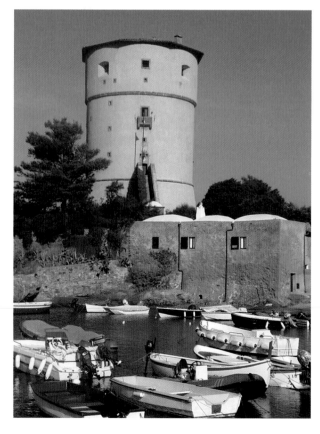

In the hotel

The picture shows a scene in a hotel – one you might see many times each day. The weather is nice, the people have gone out for the day and a young woman is crossing the hotel foyer.

THE INSPIRATION: Sometimes, it is just the small details that can attract attention. In this example, the reflective, serious face of the young woman is noticeable, as it does not seem to fit in with the lovely sunny day. You can also feel the emptiness of the room and the slight haziness of the photograph. The woman's eyes are particularly striking, standing out like white pearls in her dark face. You might think that she does not have any pupils, which gives her face a somewhat supernatural appearance.

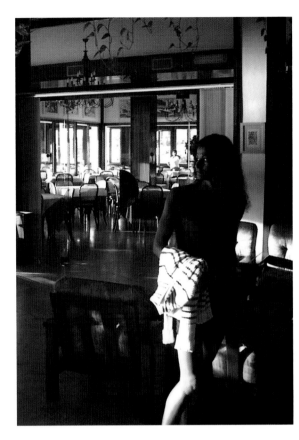

The concert

You cannot plan photographs like this. It is dark, the people on the stage are moving and the light is changing frequently.

THE INSPIRATION: With this subject it is not difficult to find a starting point for turning it into a piece of art. The smoke, the transparency of the musicians and the blue in contrast to the black will give you lots of ideas.

TIPS

It is always a good idea to take several photographs of a scene or subject, so that you can be sure that one of them will be good enough to use.

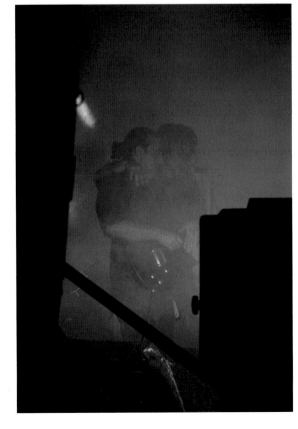

WORKSHOP

TIP

If you start by taking photographs, you will gradually develop a better eye for suitable subjects.

OPTIMISING PHOTOGRAPHS

INFO
YOUR CHOICE

Try to emphasise the unusual and unique features, i.e. what appeals to you most about the picture.

Once you have chosen a photograph, it is time to change it. First of all, you need to look at it in a different light in order to make it suitable as a model for a piece of Gothic art.

What's the aim?

How can you work on a favourite photograph to make it suitably loaded with atmosphere for converting to the dark side?

Drama: the tower

First of all, it is important to remove any colour from the picture. You will need to increase the contrast so that the photograph is virtually reduced to black and white.

TIP

The more frequently you work with photographs, the more often you will have ideas on how to make possible changes.

1 If you have a digital photograph, this is very easy to do as most graphics programs have a function whereby you can change from colour to black and white. If you do not have a computer, the picture can simply be copied using a black and white photocopier.

2 To increase the contrast, you can also use the relevant function in a graphics program. Otherwise, you can adjust this yourself using the contrast function of a photocopier.

3 To make the motif more dramatic, a stormy sky can be added. Here too you can either cut out a stormy sky by hand and stick it on or you can add it using the computer.

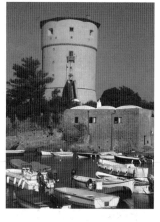

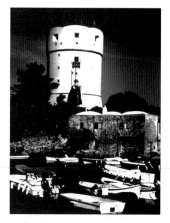

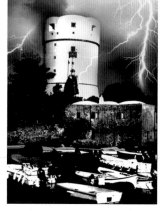

4 As a last step, the boats in the foreground are removed, either by drawing over them with a felt-tip pen or wiping them out digitally using the computer. This will bring out the black of the motif even more.

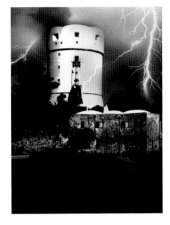

TIP

As the picture is only intended as a model for a drawing, it is not necessary to work very precisely here.

Hidden depths: in the hotel

The picture was selected as the young woman's face has a certain aura. This is why the motif has been reduced to this fragment and the colour removed in the same way as for the tower. It is important to increase the contrast, as this is the only way to make the bright gleam in her eyes really stand out.

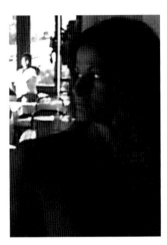
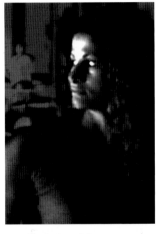

When adjusting the photograph, proceed as for steps 1 and 2 of the tower. Once you have done this, you can see the quality of the picture really well and use it as a basis for your drawing.

Pure magic: the concert

First, remove the colours from the picture as with the previous motifs. You will need to increase the contrast here too, so that the picture does not degenerate into black and grey. This will make the two musicians more clearly visible and the light will appear more magical. You can now use this model as a basis for your drawing.

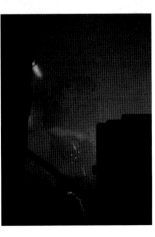
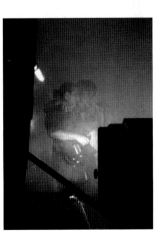

WORKSHOP

GRID TECHNIQUE

Once you have worked on a suitable photograph, you then need to transfer the motif to paper. There are various ways of doing this.

Tracing

If you do not have a lot of time and are not very confident, you can simply trace the outline of the motif on to a sheet of paper using tracing paper. The disadvantage of this method is that you will not develop your drawing skills as much as you might like.

Using a grid

The grid method is a better one. The grid helps you estimate the proportions and distances accurately. A fine, evenly spaced grid is drawn over the whole photograph. The same grid is then drawn on to a piece of paper, again with very fine, virtually invisible lines. Finally, the motif is transferred freehand, segment by segment. The picture on the right shows this method with stronger grid lines, just by way of demonstration.

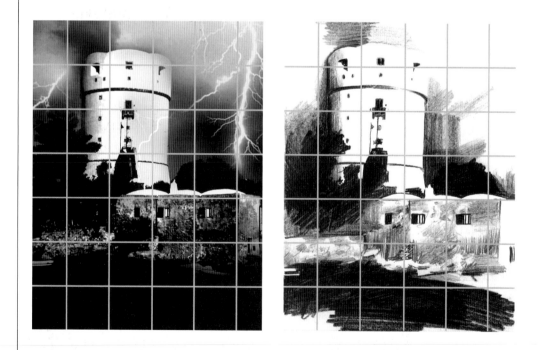

TIP

Do not be disappointed if it does not work out straight away. This method requires a lot of effort even for well-practised artists.

Freehand

If you are a seasoned artist, you can also transfer the motif to paper completely freehand, i.e. without any help. Take care, though, to get the proportions right.

THE OLD TOWER

E ach of the three versions below is a picture in its own right of the old tower, whose romantic yet spine-chilling presence speaks to us through time and space.

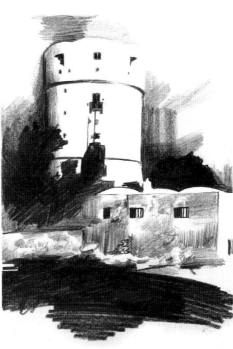

The technique

Based on the previous example (page 73), three versions of the motif were drawn on to white paper using a black coloured pencil. The motif with the largest white area almost has the appearance of a sketch and thus radiates a certain lightness and spontaneity. The dark motif, on the other hand, appears to be very heavy and menacing. This version could have been drawn to similar effect on black paper using white pencils.

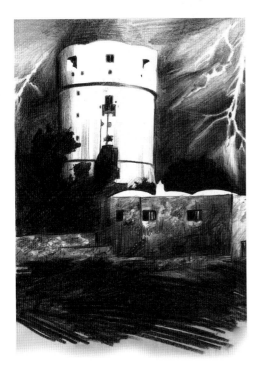

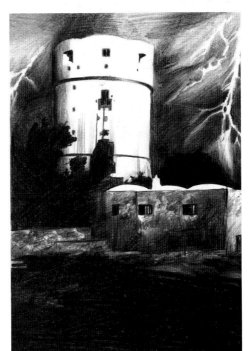

DEMONIC

Now you can capture for ever what you saw in a split second in a hotel foyer: demons are among us!

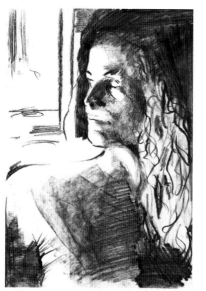

The technique

As with the picture of the tower, each stage here exists as a picture in its own right. However, the almost demonic, white eyes look best in the darkest version.
Charcoal was used to create the motif of this young woman. As with the portrait of the girl on pages 42-43, a tension exists between the grace of the woman and the rough, almost dirty effect of the materials used.

INFO
DEMONS
The term 'demon' comes from the Greek 'daimon', used to describe the spirit of a dead person – a type of being that was neither man nor god, but rather something in between.

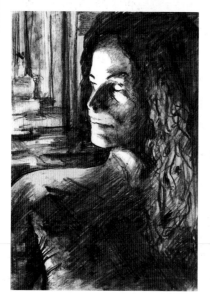

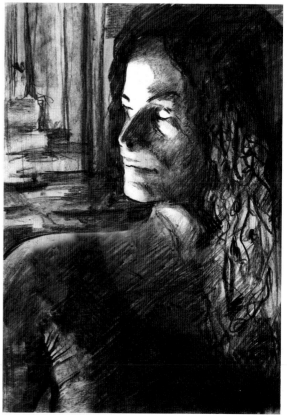

MAGIC MUSIC

Only music can really set us free. Music and dance are our strongest ways of expressing our feelings through movement – of experiencing the combined aliveness of body, spirit and soul and becoming a part of the creative powers of the universe.

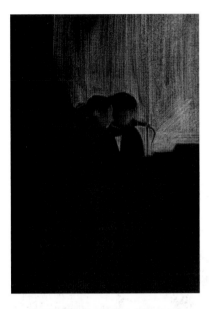

The technique

In contrast to the two previous motifs, the technique used here is of a white drawing on black paper. White coloured pencils are the starting materials here too. The three pictures show the step-by-step development of the motif. Whereas with the tower and the woman, the intermediate stages could be stand-alone pictures, the atmosphere here develops only through the strong light/dark contrast achieved at the end of the work.

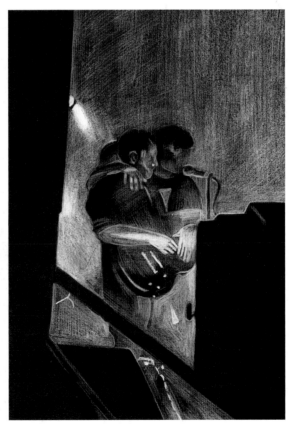

POETRY

Of course, there is far more to Gothic art than drawing pictures on paper and reducing them to black and white. As the Goth movement has a vivid feeling of being alive, stemming from the outrages of present-day life and turning against violence, terror, consumerism and the decline in values, it lends itself to being expressed in a variety of ways.

The power of words

Many followers of the scene try to give expression to their strong feelings through words and verse, which is natural, as finding words initially seems easier than drawing a perfect picture. But the real creative process lies in the combination of different methods of expression. The combination of words and pictures gives rise to a vast area of conflict. It is up to each individual whether he or she allows the words to inspire the picture or vice versa. So give your feelings free rein and try to direct the strength that comes from that into creative channels. Last but not least, this process is also an examination of yourself, through which you will develop further and discover more new things.

A poem is formed

The example of the girl with a rose is the clearest. To illustrate this, the picture was divided up into its various components.

If you look at the picture and allow your thoughts to run wild, terms that correspond to the individual components of the picture will inevitably come to mind.

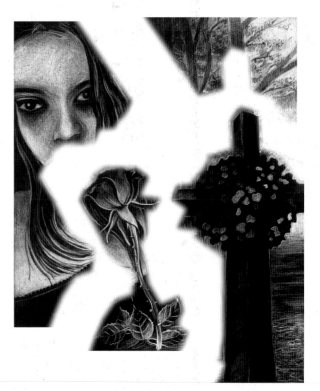

- ▶ The girl: youth, sadness, eyes, hopelessness, beauty, soul, etc.

- ▶ The cross: grave, death, cemetery, sadness, belief, religion, death, etc.

- ▶ The rose: love, beauty, transitoriness, pain, etc.

- ▶ The trees: wood, fog, light, shade, autumn, leaves, the rustle of the wind, old age, etc.

It is now not difficult to arrange the individual words into verse.

TIP

The words quoted are just some sample phrases that have a direct or indirect link with the motifs. Everyone is likely to come up with alternatives of their own.

IN THE LAST DAY OF MY YOUTH,
WITH PAIN IN MY HAND,
I STOOD AT THE GRAVE.

WITH HOPE ALL GONE,
LIKE A BREEZE IN THE WOODS,
TO SEE THE LIGHT ONCE MORE.

MY ONLY LOVE,
DISAPPEARED IN A MOMENT,
AS THE BELIEF IN ME DIED.

First published in Great Britain 2009 by
Search Press Limited, Wellwood, North Farm Road,
Tunbridge Wells, Kent TN2 3DR

Original German edition published as Werkstatt
Zeichnen – Gothic

Copyright © 2008 frechverlag GmbH, Stuttgart,
Germany (www.frech.de)

This edition published by arrangement with Claudia
Böhme Rights & Literary Agency, Hanover, Germany
(www.agency-boehme.com)

English translation by Cicero Translations

English edition edited and typeset by
GreenGate Publishing Services, Tonbridge, Kent

ISBN: 978-1-84448-476-8

PROJECT DIRECTOR: Dr. Christiane Voigt
PROJECT MANAGER AND EDITOR:
Verena Zemm
PHOTOGRAPHY: frechverlag GmbH, 70499 Stuttgart;
Fotostudio Ullrich & Co., Renningen (page 6 top);
lichtpunkt, Michael Ruder, Stuttgart (page 6 bottom,
page 7); Gecko Keck (remaining photos)
LAYOUT: Petra Theilfarth

Printed in Malaysia.